Creative Canine

PHOTOGRAPHY

Creative Canine
PHOTOGRAPHY

L ARRY A LLAN

ALLWORTH PRESS

NEW YORK

08 07 06 05 04 5 4 3 2 1

Published by Allworth Press
An imprint of Allworth Communications, Inc.
10 East 23rd Street, New York, NY 10010

Cover design by Derek Bacchus
Interior design/page composition/typography by Sharp Des!gns, Inc.

LIBRARY OF CONGRESS CATALOGING-IN-PUBLICATION DATA
Allan, Larry.
Creative canine photography / Larry Allan.
p. cm.
Includes index.
ISBN 1-58115-321-X (pbk.)
1. Photography of dogs—Handbooks, manuals, etc. I. Title.
TR729.D6A43 2004
778.9'39772—dc22
2003020911

Printed in Singapore

Dedicated to My Sweetheart,

My Helper,

My Inspiration,

My Wife, June.

Contents

Foreword

After reading just the first four lines of this book, I rushed to my wife and asked her whether she had ever heard Larry Allan's advice about how to approach a strange dog. She hadn't. After reading it, she remarked that the value of this information could go far beyond taking pictures of animals. "It should be taught to every child in kindergarten," she said, thinking of all the children who didn't know how to approach a dog, and of the sometimes unfortunate and unnecessary consequences that can ensue.

While this is not a blanket recommendation to share the complete contents of this book with pre-first-graders, Allan's love, knowledge, and suggestions for making friends with canines is for everyone. Actually, you are holding not just one book, but three books neatly blended into one. First, there is the book about the animals themselves—dogs, wolves, foxes—what they can learn from you and what you can learn from them. Then, there is the know-how for photographing the animals—not just what lights, camera, exposures, etc., are needed, but little-known tricks of the technical trade. Have a panting dog and want to get that long tongue back inside before you take the picture? Don't try shoving it back in or shutting the dog's mouth! I won't spoil it for you by letting it slip about how simple it is to solve this one. Like the spaghetti sauce commercial, it's all in there.

How much must you know about the technical side of shooting canine pictures, such as choosing camera, lenses, films, determining exposure with and without flash? Allan chose the best—and toughest—educational technique: teaching in simple enough terms that a snapshooter can learn quickly, while not talking down to knowledgeable photographers. He advocates using fill-flash, and here you'll find a wonderfully simple way of determining exposure for it—good for beginners and pros alike.

Although I'm accustomed to determining depth of field (the foreground-to-background distance I want sharp in my photographs), I had never tackled depth of field for dogs—principally the distance between the eyes (where your focus should be) and the dog's nose. Not only should the dog's eyes be sharp, but its nose as well. While you often can get away with a blurry human nose, a fuzzy, leatherish nose on a Brittany Spaniel won't do. And not all dogs are the same. For example, while a Pug's features are virtually all on one plane,

the Spaniel may need a higher ISO-speed film for greater depth of field than a Pug, just to take care of that nose!

What will really inspire you, though, is the third part of your canine indoctrination: admiring and analyzing Allan's splendid pictures, which feature subjects that run the gamut from simply shot, friendly, unkempt, yet adorable mixed breeds to highly coiffed champions photographed with professional photo equipment.

Many photographers who are writing and illustrating photo books carefully screen out all but their very best work. Allan is careful to include photos that detail how to improve a so-so photograph by using the dog's owner to get the dog to change expression, how to coax a dog from being a reluctant and scared animal into a confident and comfortable one, and how to prop up a dog's confidence (and his body) by letting the owner hold the dog outside the picture-taking area.

It's obvious that Allan photographs canines magnificently and with great affection, knowledge, and an ability to communicate it all to everyone who melts wherever and whenever a tail wags. He can't wait for the next four-footer to trot up his street or pop into his studio for a formal portrait. His pleasure is infectious. Just you wait and see!

Herbert Keppler, Publishing Director,
Popular Photography & Imaging *magazine*

Acknowledgments

Almost every book written represents the work of many people, no matter how many names might be on the cover. This book is no exception. I'm grateful for the help of others, some whose assistance far preceded the writing on these pages. The incomparable Victor Keppler was a good friend, and a wonderful inspiration. Brian Johnson, a marvelous wedding and portrait photographer, took the time to help a fellow photographer begin on an unusual, and wonderful, new career path. I very much appreciate how much they contributed to my efforts here.

Writer Jalma Barrett helped direct my thinking in the formulation of this book, and offered solid advice whenever it was sought. My heartfelt thanks to her.

I'd like to thank the many folks at Allworth Press who contributed so much to this book, especially publisher Tad Crawford; editor Nicole Potter; associate editor Elizabeth Van Hoose and editorial assistant Jessica Rozler; and art director Derek Bacchus. Their aid and direction made this task a joyful and rewarding one.

And finally, I must thank all the many people whose canine companions appear on these pages. I'm so pleased they brought their dogs into my world, if only for a little while. It's truly been a wonderful and joyous experience knowing them.

Introduction

You might be wondering why I chose to title this book *Creative Canine Photography,* especially when your reason for reading it is to capture better photographs of your—or your friend's—dog. Why not just call it *Better Dog Photography,* or *How to Get Better Photos of Dogs,* or something like that?

First, because I'm an animal photographer (I photograph dogs, cats, birds, horses, wild animals, etc.), I've included information about photographing wild canines, too, for those readers who want to improve their photography in nature. In North America, the wild canines are coyotes, foxes, and wolves. You'll find them on these pages, along with all sorts of wonderful dogs.

I chose to use the word "creative" to reflect my opinion that every canine we meet is an original, a unique being. And we all want our photographs to reflect that originality and uniqueness. I don't try to do that by dressing up our four-legged subjects. I capture their individuality photographically. But in order to be successful animal photographers, we must be creative in our approach to the animal we're photographing, creative in our use of light and the equipment we use, creative in our interaction with—and motivation of—our subjects, and creative in our presentation of the final image. This book was written to help you with all these creative decisions.

The dictionary defines "create" as to cause to come into existence; originate, produce, or bring about. That's what we're doing with our photography of canines. Since I especially enjoy the creative aspects of animal photography, I won't burden you with big doses of technical stuff, although, if you must have it, you'll find technical details included. My advice to you: Don't let the technical side weigh you down! Enjoy those wonderful canines—and enjoy the photographs of them that you create!

Oh, yes, this book was also written to point out to you that there is no single creative solution to all your animal photography needs. I hope you gain a lot of helpful and usable information from my quarter-century of experience successfully photographing canines of all kinds. May the sights, sounds, and smells of your experiences photographing canines—be they domestic, or wild and free—sustain you, and give you peace, contentment, and joy as you pursue the satisfaction of creating canine photographs.

Larry Allan

 SECTION 1

Let's Begin

I've incorporated information in this book that will assist you with your photography of canines—no matter what your level of experience. To begin, let's get acquainted. While you might find section I a bit too basic, especially if you've had years of experience living with and working with dogs, I want to refresh your memory with some of the things you did when you first met and began photographing your present canine companion. After all, you'll probably be meeting lots of new critters, and photographing lots of new situations, as you pursue creative canine photography. New photographer, advanced amateur, professional: I believe I've included valuable information for you. 🐾

Sniff the Hand: Getting Acquainted

When you meet a dog for the first time, it's just natural for you to put out your hand in a fist (that's less threatening to the dog than with your fingers extended) so your new canine friend can sniff the back of it. It's a well-known way to get safely acquainted with a dog.

I know you like photography. And I realize you know, and love, dogs. Me, too. Here's my hand. This is where we begin your adventure of creating better photographs of canine subjects. In the twenty-five-plus years I've been professionally photographing Afghans and Bulldogs, Corgis, Dachshunds, and Fox Terriers, German Shorthaired Pointers, Golden Retrievers, Kuvasz, and mutts, Pomeranians, Rottweilers, Salukis, Schnauzers, Tibetan and West Highland White Terriers, and more, I've learned lots of techniques and tricks. And I'm going to be sharing them with you in these pages.

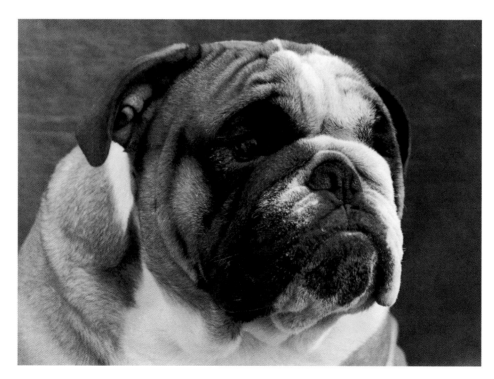

A studio-style portrait of a Bulldog. The point of focus is the eyes.

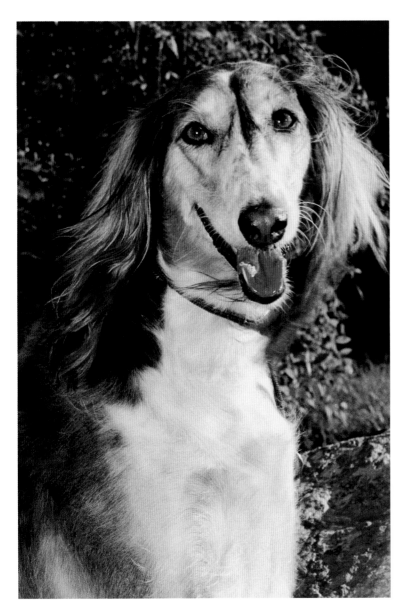

An environmental, or candid, portrait of a "smiling" Saluki. Again, the focus is on the eyes.

I sat right down on the ground to capture the serenity reflected from the eyes of this handsome English Setter. Before I photographed him, I took the time to get to know him, and he got to know me through my petting him and speaking softly to him. We related. He relaxed.

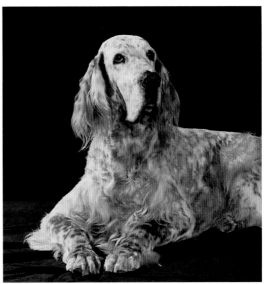

Wild Canines, Too

It may surprise you to learn that many of the techniques that helped me capture the photographs of dogs you've seen in magazines and books, on calendars and greeting cards, on product packaging, and other places, can also be applied to the photography of wild canines—wolves, foxes, and coyotes. I'll show you how I captured their photos for magazines and books on these species, as we progress.

Get Down on the Floor

It's my guess that you respect animals as fellow inhabitants of this planet. And those animals probably fascinate you, as well. If you share your home with a companion animal, you have even more reason to try to improve your photography of that furry, four-legged member of your family. Canines do make wonderful, though challenging, photographic subjects. If your subject is someone else's companion animal, then take the time (this should take you about ten to fifteen minutes) to get acquainted with the dog before you try to photograph it. Yes, get down on the floor; place yourself on the animal's level.

Reaching down from above with an open hand can be threatening to a canine; looking directly into a canine's eyes can also be a threat. Relate. Relax. If you're relaxed, the dog will relax, too. Let it sniff the back of your fisted hand. Stroke it softly. Move slowly, especially if you're moving toward the dog. You don't want to surprise it, or scare it. Talk to the dog in a soothing, soft, calm voice. You want to earn the dog's trust. Make it feel your respect; make it confident of your friendship. Dogs do respond positively to the love and affection you give them, but it must be real. As for wild canines, don't try this step with a wolf!

If your favorite canine photographic subject shares a home with you, you've probably already tried photographing it. Maybe that was in the yard or on a run in the park. Maybe the dog was just being itself somewhere in a

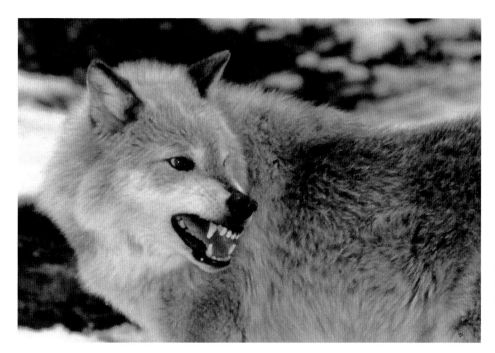

Just a reminder: This is why you should not try getting to know a gray wolf in the wild. Actually, the animal was not threatening me, but rather was reacting to another member of its pack.

favorite spot around the house, perhaps in the family room. If a dog feels comfortable with its placement when you make a photo, you'll just naturally get better results. Have the patience to wait for "the moment" to happen, and be ready to capture the action when it does.

Advance from Taking Snapshots to Making Portraits

Now, you're reading this book because your photographs weren't, perhaps, as good as you wanted them to be. You've probably got scores of on-the-floor snapshots of your canine friend, but familiar surroundings alone aren't helping you step up to that next photographic level of excellence. If your photographic results are inconsistent—some good, some terrible, and lots of photos in-between—this book will help you get consistently good results. I want you to be able to achieve your photographic goals.

When my wife and I started photographing dogs seriously, it was because we'd just unexpectedly lost a much-loved Pembroke Welsh Corgi. Her name was Harmony, and she was only two years old when she died. After she passed on, we realized that we didn't have any good photographs of her—that is,

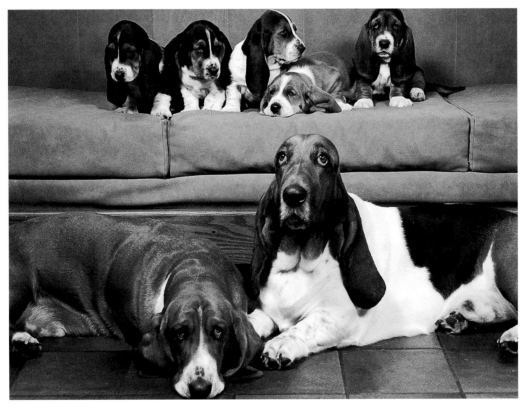

This pair of adult Bassets settled on the floor in their family room. It was their usual place. We positioned their pups on the sofa behind them. What adds impact to this photo is the position of the litter's mother, head down, as if she's worn out from her parental duties. The look-alike puppy's mimicking pose behind her is a plus. It just happened. It's hard not to take a great photo of Basset Hounds.

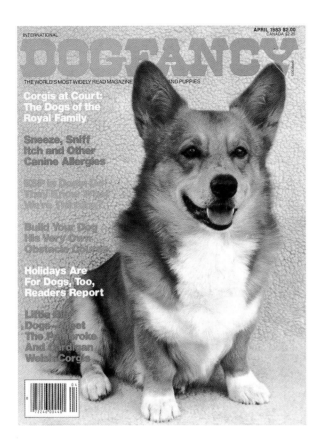

This portrait of a Pembroke Welsh Corgi was used on the cover of *Dog Fancy* magazine.

portrait-quality photos. What a thing for a photographer to have to admit! We simply assumed she'd be with our family a lot longer than that short span of slightly over two years. It was then my wife, June, and I began to talk about the need for professional portraiture of dogs. We were sure we weren't the only people who felt this way about our companion animals. While our business now includes wild, as well as domestic, animal subjects—cats, birds, and other species—we started with dogs. And we now produce lots of photographs that definitely would not be called portraits, either. By the way, the photos we've made of the companion animals who have shared our home since Harmony are a treasured part of the family photo gallery in our home today.

We'll share what we've learned—and help you achieve unbitten success, too. After all, we've made the mistakes others make. You'll learn how to create formal-looking (studio-type) portraits and environmental, or candid, photos. The quality of these two types of photography should be the same; only the setting varies. You'll learn how to get better action shots and group photos, too. And you'll learn how to get your subject to sit still, how to pose your dog, how to light it, even how to cause, and capture, your dog's different expressions.

I'm going to assume you have (or have access to) a 35mm camera—and

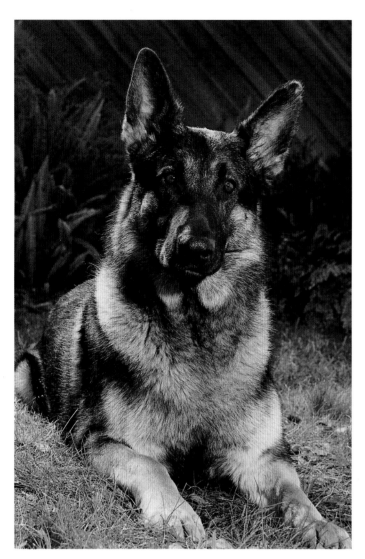

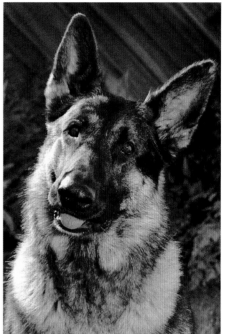

LEFT: This German Shepherd posed himself beautifully, but I still had to get him to put his ears up and give me that intelligent, interested look. All I had to do was ask his owner/companion to walk around the corner to get out of the dog's line of sight. The dog watched him carefully as he left, and I captured this intense look. BELOW: By the way, the German Shepherd got an entirely different expression when I asked his owner to come back around the corner. And here is the expression I captured when the dog's companion reappeared.

a dog. If your camera is of the point-and-shoot type, don't worry. Lots of what you'll be learning here in this book will apply, and the technical stuff won't get in your way. Some thoughts about cameras, lenses, and films are coming up later. Let me assure you there's no need to run out and spend hundreds, or thousands, of dollars on special equipment in order to create better canine photographs.

Film-based and digital images both result from capturing an image formed by light that's been focused through a lens. That is photography. Only the information retrieval system, or image delivery, is different. Whether you use a film camera or a digital camera, the information you'll get on these pages will assist you. Work with what you have. Then add equipment as you find it necessary, advantageous, or simply desirable.

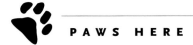
Grooming Tips

A clean, well-groomed, and brushed subject is definitely going to come out best—unless you're trying for a special effect, as we did in this humorous photograph of a Yorkshire Terrier with a "fly-away" coat (below, left). This photo became a top-selling greeting card with an appeal that has now lasted more than nine years.

Avoid bathing and photographing your canine subjects the same day. And avoid photographing dogs whose coats are clipped too close. Examine the corners of your subject's eyes. Gently remove any "tear matter." If the corners of the eyes are stained, a little corn starch on a white dog or charcoal on a black dog will help disguise the problem. Be extremely careful not to get any of these "cover-up" materials directly into the dog's eyes. Note: In order to see this Yorkie's eyes under those "bangs," it was necessary to get down under the dog's line of vision and photograph with the camera tilted up. We all love to look into an animal's eyes. Plan your shot to get what you want.

Watch out, too, for slobber or drool, which happened in this shot of a Gordon Setter (below, right). Keep a small towel handy to wipe up around the dog's mouth whenever it's necessary.

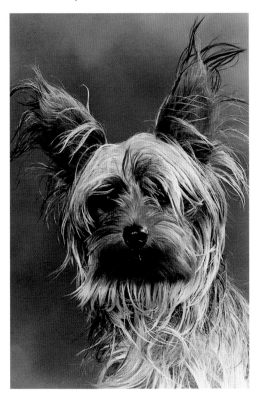 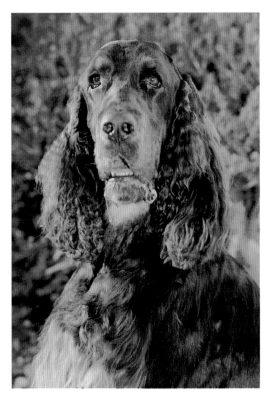

Scratch Behind the Ear: Think, Study, Visualize

Okay. You've had your hand sniffed; then it was licked tentatively a time or two by a precious pup. You're comfortable with each other. There's trust. You're going to have fun. But, remember, it's your responsibility to make all your photo sessions fun for your canine subjects, too. A positive, upbeat attitude will put your subjects at ease, and help you create canine portraits that'll please everyone, including yourself. If "enjoyment" is part of all your photographic sessions, you'll be able to eliminate most problems before they happen and increase your chances of photographic success. Here in chapter 2, we'll talk about what you want to capture in your photographs of dogs.

Now, here's a unique thought: before you load your camera and begin snapping away, think. Think about the kind of photo you want to create. While you scratch your canine subject behind the ear, visualize. I've often heard that athletic coaches tell players to visualize the bat hitting a pitched baseball or the basketball going through the hoop after a shot in order to achieve improved results. And it works! Your photography can improve from that kind of visual energy, too.

Copy or Create

You may simply want to copy one of the examples in this book. That's okay. I'd be flattered. But you might have something entirely different in your mind's eye than what you see on these pages, as well. The point is—have something specific in mind. If you don't already have an image or two popping into your head, look at canines on calendars, billboards, or posters, in magazines, books, or other printed media. When you watch television or go to the movies, make mental notes when you see images you enjoy, or images you find yourself reacting to in a positive way. My wife and I still do that. It's a great way to keep your creative juices flowing.

Hopefully, you'll get the same kind of pleasant surprise we got one night when we went to see the movie *The Truth About Cats and Dogs*. There was a scene showing the lobby of a radio station. On the wall were photographs of

This photograph was used in the movie *The Truth About Cats and Dogs.* The cat settled down on the posing table, and we "arranged" the dog behind it. Ideally, we like to see some touching between subjects when the photo includes more than one animal. We were very watchful, ready to prevent any possible conflict between these two mixed-breed subjects if any trouble developed.

the station's on-air personalities—except one, the female veterinarian who did an advice show about cats and dogs. Representing that particular personality was one of our photos of a dog and cat. It took me a moment or two to realize the movie camera had zoomed in on one of our photographs. Of course, I recognized it—just as I'd recognize a photo of one of our children. Agents handle the sale of our photos, so we don't always know who bought what photo, or for what purpose or end use the photo was purchased.

By the way, when you search for ideas on paper, don't limit your reading to just photography publications. Yes, they can be inspiring, as well as full of solid information, but you can get creative jolts at art galleries, too, especially at exhibitions of photography. Ideas for photos of dogs can also be garnered

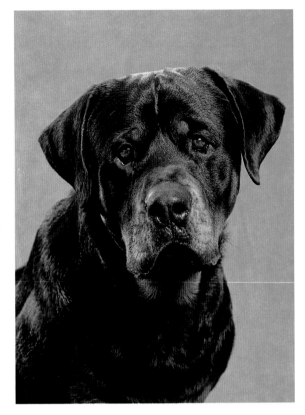

Increase visual impact by eliminating unnecessary elements. Both highlight and shadow areas should have detail and texture, too, as in this Rottweiler's photo.

from photos of babies and young children, we've discovered. I actually got some ideas for our photography from looking at photographs of cars. Great photographic ideas can be found everywhere.

As you look at photography (and art), look at composition, cropping, and color. Look to see if elements that aren't essential to the visual message have been eliminated. This gives added importance to your subject, increasing the visual impact of your photograph. When you pick up your camera, look around the edges of the picture as you set it up, before you click the shutter. Note how clean those edges are—or aren't. Eliminate unnecessary elements or visual distractions.

You'll quickly learn to recognize picture quality. Both highlight and shadow areas should have detail and texture. And good composition, too. By looking at the photography of others, your awareness of what is photographically good will develop and expand. You're already doing that right here in these pages. You don't have to marvel at every image you see here. You don't even have to like all these images of ours, but you're learning—almost by osmosis—to develop your own tastes of what creative and successful photography of canines ought to be. Your photographic results will reflect what you're learning here, just like magic. But make sure those photos reflect you, your taste, and your personality, not someone else's.

 PAWS HERE

Plan Ahead

By visualizing your end result (a photograph), you set a goal for yourself, just like those baseball and basketball players I talked about. Without a goal, you limit your own chances of success. But, by setting up the shot exactly as you visualize it, you'll be able

to create virtually anything. Creative success will follow. Yes, just as surely as one dog will sniff another when they meet, your photography will reflect the thought, effort, visualization, and planning you put into it.

The goal of the photo session with this Cocker Spaniel (below, left) was to capture him just being himself in his own backyard. The late-afternoon sun provided the main, or key, light, coming in from the viewer's left. Fill flash from the front added detail in shadow areas. It was a windy afternoon, but I like the feeling of motion shown in his wind-blown ears and coat.

The goal of the shoot of this Shetland Sheepdog (below, right) was to capture a more formal portrait. We used a hand-painted, sky-blue background, main light from the viewer's right, and fill flash beside the camera. The Sheltie was sitting on our sturdy posing table for this pleasing shot.

Of course, your first creative decisions will tell you what you'll need for background, and for lighting, and those decisions will determine which film is best to use. Your creative decisions will even affect your choice of lens. Later, in section II, I'll share more information to help you make those decisions.

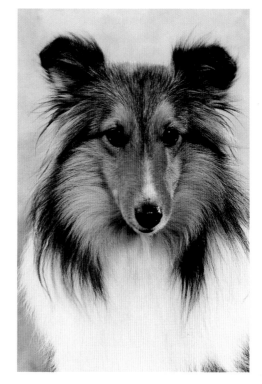

What Part of "Woof" Don't You Understand?: Learn About Dogs

Well, let's see . . . "A dog is an animal with four legs, two ears, covered in fur." You don't need that kind of definitive introduction to our subject, I'm sure. But there are some things you probably already know about dogs that I want to remind you about, because they can have great impact on the level of your success creating the kind of canine photographs you want.

While certain canine behaviors can work for you, other normal reactions can work against you. The important thing to remember is that you have to be aware of what is happening with your canine subject. Be observant. I've already talked about some of these things—eliciting different expressions from your subject and grooming. Here are a few additional things to watch for.

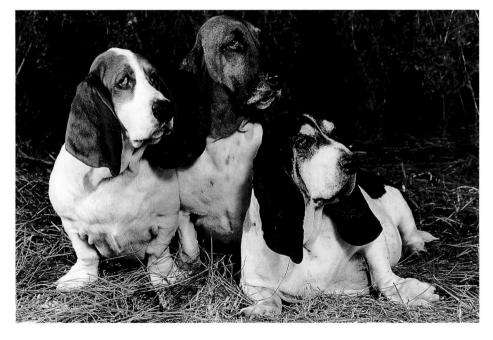

This trio of Basset Hounds was in a public park for their photo session. Their attention went three different directions at once. How did we get them to all look in the same direction? We put out bits of bread—for the pigeons! The dogs watched the pigeons feed, and we got a well-directed group of subjects.

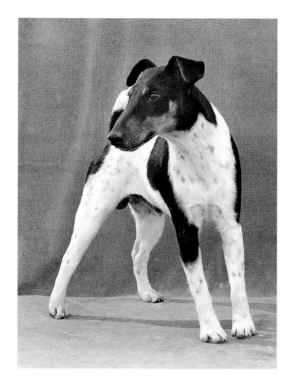

This Fox Terrier shows all the wonderful attributes of the breed's outstanding personality. He's perfectly comfortable, for the moment, on our posing table. But who knows where he'll be one minute from the moment of this exposure? Though unorthodox, I believe this photograph shows both the strong good looks and the energetic essence of the breed.

Attention Deficit

First, a dog's attention span is short. About ten minutes of photography is all you can count on. Then your subject's attention will wander. Once I'm set up for photography, ten minutes is enough time for me to relax my subject on a posing table, then capture five to ten photos. Using sounds or other attention-getters, I'll get my subject to look into the camera, then to the left and to the right, look up, look down. During these initial ten minutes, the dog might change position (or pose) once or twice. But I try to keep going, working to maximize whatever I'm being given by my subject.

A Fox Terrier we were trying to photograph actually took off running once. We were working at a dog show, and, after being assured by the dog's handler that the dog would stay, we advised the handler to take off both collar and lead (I do prefer to photograph dogs without collars, harnesses, or leads). I guess the Terrier hadn't been listening, because it suddenly left—at full speed, like any Terrier can. There was no way we'd be able to catch the high-speed Terrier. A woman waiting her turn to have her Bearded Collie photographed, volunteered to let her dog go after the Terrier. She released the Beardie, a herding dog, with a spoken command that I didn't hear, and, yes, the Beardie did round up the Terrier! No harm done. I mentally bestowed a red cape on the Beardie that day.

Take a break every ten minutes or so. Let the dog change position, move around, maybe even play a little bit. Careful, don't heat up the dog so it's panting when you decide to return to your photographic efforts. The important thing for you to remember is to call a halt to your photography whenever you see the dog getting bored or restless—for instance, yawning or simply looking around, unfocused. A short break is good for both of you.

Note Your Subject's State of Mind (and Body)

Also, read the signals your animal subject is sending you while you're photographing it. You already know how to react when a dog gives you a menacing stare, raises its lips to display those long canine teeth, and growls. But, if the dog simply raises its hackles or looks toward you with a defiant stare, call a halt. These signs of aggression are important. Pay attention. It's vital that we all watch for "telltail" danger signals.

A sign I've seen much more frequently than aggression is submissive behavior. This can include lowering the animal's front paws, dropping the chest down, looking away, dribbling urine, rolling over, and avoiding someone's touch. These behaviors lead to an absolutely horrible photographic experience. Some dogs seem to turn to jelly on the posing table. They just won't stand or sit. One little puppy simply slumped down, as if we'd let all the air out of a canine balloon. We'd try to move it, and it would collapse down on the

A

B

C

There's no doubt about this elderly Cocker-mix being relaxed and cute.

table. Eventually, our reassurances put bones back into those rubbery legs, and confidence back into our very young subject.

In photographs A, B, and C (page 16), you can see the progression of a pup's look from reluctant and scared to confident and comfortable. At first, this mixed-breed youngster looked very skeptical about the process and unhappy with what we were doing. Later, I caught some cute expressions, like the one in photo B. Finally, I was able to capture a nice portrait of that same mixed-breed puppy—no longer reluctant, no longer scared, but looking proud and confident. Patience and loving attention pay off when you're photographing canines, especially very young ones.

No one wants a photo of his or her canine buddy with a scared, "hang-dog," expression. If you encounter an especially submissive animal, give it more time to warm up to you, to become comfortable in the situation into which you're placing it. Bring the owner/companion in to help relax the dog. Try to get the dog to play. Then return to your photographic session. Hopefully, you'll get pleasing results, as we did with that rubber-legged little canine.

A relaxed dog will be standing with its weight evenly distributed on all four legs. It will look comfortable, ears soft, though they may be hanging down or standing out to the sides, depending on the breed. Its tail will be down, perhaps with a slight bend or curve, or it could be curled over and resting on the dog's back. Again, this varies with the breed.

A good photograph of a happy dog will always bring a smile to your face. How did you react to this tail-waggin' photo of a delightfully happy mixed-breed dog?

Avoid the Fear Factor

A dog will draw back away from you if it suddenly becomes fearful. Its weight will be on its rear legs. It might slouch or look away, as many submissive canines do. The eyes will open wide; the ears will lay back; the tail will drop between its legs and rest up against its stomach. Fear is evident. Some dogs, especially the smaller breeds, can show fear through trembling. If this happens to your subject, for whatever reason, stop your photography. Remove the cause of fear, if you can. Take the time to reassure and relax your subject. Food treats can help. Bringing out a favorite toy for a few moments of play can also help dispel the fright. Once the look of fear is gone, then you can return to your photography.

That Happy Look

And finally, we all know it when we see it. A happy dog!

That happy look is a great look. One we all want to photograph. Some canine subjects even look as if they're smiling. The dog is leaning forward a little bit, looking eager. Perhaps the tail is wagging. I've even seen them appear to "wag" their entire rear ends. Capture that look. You'll love it. And the dog's owner/companion will love it, too.

The important thing for you to remember is to be aware of your subject. Read the signs, the messages, the dog's behavior is sending you. These messages can be sent through body language, or they can be sent vocally. Be attentive. Respond to the messages you receive. You'll end up with better photographs because you watched and listened, receiving those incoming messages from your canine subject. More information on utilizing normal canine behaviors is coming later on, in chapter 12.

 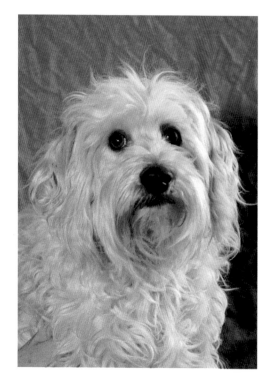

Our "happy dog" didn't always look that way during our photo shoot, as these two additional photographs show. Note the hand of the dog's companion person in the lower left corner, reassuring the dog and helping keep it in place. But the dog did react positively, relax, and enjoy what was happening, as the photo on page 18 demonstrates.

CHAPTER 4

Bow, Wow, Click:
Learn About Your Equipment

'**F**ess up. Have you ever read the instruction manual that came with your camera? I mean, have you really read it, camera in hand, trying out all the various functions discussed on those unturned pages? Tell me the truth, now!

I can't read it for you. That's something you'll have to do on your own. But I can tell you that whenever I get a new camera (about every two years), I actually sit down with the manual and the camera and try out every function the book discusses. I familiarize myself with my new equipment right away. Then, hopefully, when I'm photographing, I'll be able to get that camera to do exactly what I want it to do—from day one—without having to refer to the instruction manual one more time. After all, it isn't just knowledge of animals that will lead you to success in canine photography. You have to know your equipment, too.

And, just in case, to be prepared, always carry that instruction manual when you're out photographing. You never know when you'll need to refer to it in order to make a change or adjustment that you can't quite remember how to do.

Speaking of instructions, it's a good idea to learn the exposure information manufacturers pack with their films. You'll then be able to recognize whenever your camera's built-in metering system is giving you a variation from that "norm." It might then be time to visit your local camera repair service to check out your camera. Yes, cameras need regular servicing, just like cars do. They need to have the dust and grit cleaned out, they need lubrication, they even need to have their calibrations and timing checked. When was the last time you had your camera serviced?

Basic Camera Handling

There are some basic camera handling techniques you should know. It's important to learn how to hold your camera steady and sque-e-e-eze the shutter button. Too many beginning photographers punch at that shutter release

These camera handling techniques will help you achieve the photographic results you're seeking.

button—and carry this bad habit forward into years of photography. Don't let your camera move while you're squeezing the shutter release.

To prevent camera movement, grasp your camera firmly, then press the camera against your face. Keep your elbows in against your body for both vertical and horizontal shots. Plant your feet apart, one foot slightly ahead of the other, so you feel well-balanced. Place your eye against the center of the viewfinder so you don't accidentally crop your subject. And line up the horizon correctly. Hold your breath when you push that shutter button. Remember, no punching, please!

35mm Film or Digital?

I've worked with 4 × 5, medium-format, and 35mm cameras. They've been rangefinder, twin-lens reflex, single-lens reflex, and autofocus cameras. I've had a choice of cameras when a particular photographic challenge came to me. As films have gotten better, finer-grained, the trend has been toward smaller cameras—35mm and its equivalent in digital imaging.

Digital cameras can provide high color accuracy, they provide instant

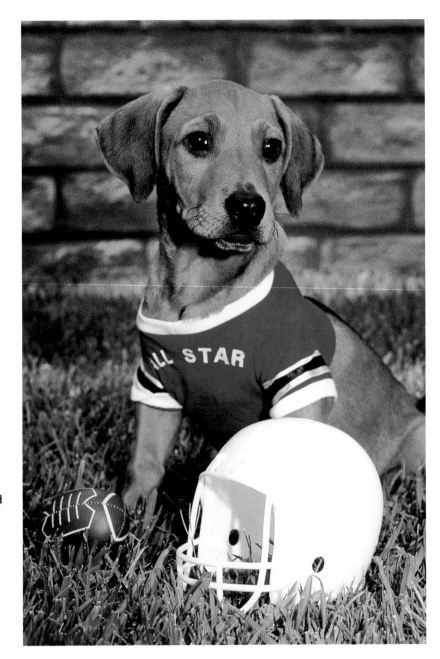

I got down on the ground to photograph this mixed-breed puppy in football gear with my 35mm camera. I used a short, telephoto lens so I wouldn't have to be right in his face. Notice the lines on the wall in the background are parallel with the edges of the photo.

viewing, and, of course, they allow quick uploads for e-mail use. However, digital cameras, currently at three or four times to twenty-five times the cost of film cameras, cannot yet match the image quality available with 35mm film cameras. For instance, using 100-speed film, a 35mm color negative contains twenty-four to thirty megapixels of information (memory), while a top-of-the-

line digital image presently contains about six megapixels, though new digital cameras are being introduced which record eleven to thirteen megapixels. Researchers are currently working on technology that could produce images even tighter than the resolution of grain structure now produced in film. But this new technology isn't quite here yet. However, a leading photography magazine recently proclaimed that one new digital camera has matched film's ability to record data, so keep your eyes peeled.

You'll also get better-quality enlargements from film than from digital images, due to digital's lack of both grain and color accuracy. However, digital images do compete well with prints from film up to twelve inches by sixteen inches in size. Technology keeps improving, so continue reading and learning about new developments in both film and digital arenas. You may want to have both film-based and digital cameras in your equipment bag available to use, depending upon how you plan to use the images you're creating. Soon, I'm sure we'll see cameras that combine these two marvelous imaging technologies.

Medium-Format versus 35mm

Many of the photo illustrations in this book were made with a single-lens reflex, medium-format camera. The advantage of a 2¼" × 2¾" (6cm × 7cm) image is its versatility. You can drastically crop the image, creating 16" × 20" or larger prints from just a small portion of the negative. Even heavy-handed cropping of a medium-format negative can leave you with a larger usable source than a full-frame 35mm negative.

Today, my first choice in cameras is autofocus 35mm single-lens reflex (known as SLRs). They're so easy to carry, to use, and to edit—plus, they are versatile. While magazine and book publishers still love a larger image, they're used to working with the 35mm format. They find that it can reproduce well, even as a two-page spread. And I have found I can produce 23" × 35" art prints of excellent quality from 35mm using today's fine-grained films as my source.

There is one big disadvantage to photographing animals with a 35mm single-lens reflex camera, and it is caused by the way those cameras function. Simply put, you place your eye against the back of the camera body to see the image your lens is getting. Since you will be photographing canines with the camera at your eye level, this means you will have to spend a lot of time on your belly, or on your knees. You must get to the animal's eye level, whether you're photographing a small puppy or a Great Dane, Scottish Wolfhound, or one of the other "tall" breeds.

Some medium-format cameras are constructed for waist-level view finding. This means their ground glass viewing screen is on the top of the camera body, so you'll be looking down to see the image your lens is picking

There was no need to get down on the ground to photograph this handsome Great Dane. He was sitting comfortably on the ground, and I could photograph from a slightly bent position directly into his face through the waist-level viewfinder of my medium format camera.

up. This arrangement is a lot easier on the photographer who's photographing smaller animals on the ground, as well as the seated taller breeds.

Glass, Glass, Glass

If your camera is capable of accepting interchangeable lenses, you need to be aware of what various lenses will do. Today, the number of lens options available is doggone immense. If you're doing your photography with a 35mm camera, your "normal" lens is 50mm, or a zoom lens that includes the 50mm

This photograph of a mixed-breed dog only represents 25 percent of the original medium-format negative, which included most of the dog's body. Suggestions about cropping your images are detailed in chapter 15.

focal length. If you're shooting medium-format, "normal" is probably 90mm. In each of those formats, the normal lens is the focal length that "sees" pretty much what your eye sees.

Most of my canine photography, however, is done with short telephoto lenses. Of course, if I'm taking pictures of wild canines in the field, I use long, or very long, telephoto lenses (some are zoom lenses, too). I use telephotos to accommodate the comfort zone of my subjects. Though many domestic canines will allow my working "up close and personal," putting some distance between us allows my subjects to relax more because they're less aware of my camera and me. I believe that I end up with better photographs because of that separation.

When I'm using my medium-format camera, my lens of choice is 127mm (remember, 90mm is "normal"). When using 35mm equipment, I generally use a short zoom—up to 105mm. Occasionally, I'll use a 70–210mm lens. Zoom lenses do provide a quick and easy way to compose and "crop." In the field, when I'm photographing coyotes, foxes, or wolves, I'll use up to 400mm. Sometimes I use a tele-extender that increases my "reach" to 560mm. Many wildlife photographers rely on 500–600mm lenses, keeping tele-extenders available for greater subject magnification without intrusion on the subject's space. These longer lenses also provide greater safety for photographers; both subject and photographer are served by maintaining distance

A large grooming table provides a solid place for this young Doberman Pinscher to relax for his photo. I've covered the table with the background cloth to hide the black rubber surface and shiny metal edges of the table.

through the use of long lenses. They can allow you to get close-up shots of very shy animals, sometimes without your subject even knowing you're photographing it. Remember, the longer the focal length of the lens you use, the more important it is for you to use a sturdy tripod to steady your camera and lens.

Of course, there will be times when you want to get in very close to your subject. For that type of photography, you'll need a macro lens. My macro for my 35mm cameras is a 50mm lens. Don't rely on the macro function of telephoto zoom lenses. You'll be disappointed and frustrated when you try to use them for those special macro, close-up, subjects.

Extension tubes, metal tubes positioned between the lens and the camera body, can also enhance close-up photography. The longer the tube, the greater the distance between the lens and the camera, the larger the image on the negative will be. Only cameras with interchangeable lenses can accommodate extension tubes. Be aware, because the light must travel farther from the lens to the film when extension tubes are added, exposures must be compensated or increased. The amount of change depends on the width of the tube.

Also, keep in mind that you can create stunning close-ups through cropping your images. Get in as close as your subject and your lens will allow. Make the picture. Then crop in even tighter in the darkroom, or in the computer, to create the special tight, macro photograph you had in mind in the first place.

Steady Camera, Steady Subject

I've already mentioned the need to steady your camera and lens with a tripod. I want to warn you that a light, easy-to-carry "pocket" tripod will probably not provide your equipment with the degree of support required. This is especially true if you fully extend the legs of the tripod. My advice: a heavy tripod is better than a light one. But be aware that tripod manufacturers are responding to this need by using lighter-weight materials. Check out the new models as they are reported on in photography magazines and as they become available in your camera store.

When you're doing portraiture of canines, especially of small and medium-sized breeds, you'll find it helpful to have a sturdy posing table. I use a large grooming table, available at pet supply stores. I cut it down in height a bit, since I'm of average height myself. That's for my comfort, not the subject's. This table provides a "sure grip" rubber surface and very steady legs, giving my subjects a stable platform on which to sit or stand. That is for their comfort. And I don't get worried expressions! This way, my smaller subjects are brought up closer to my eye-to-eye level, saving me from having to bend over or squat for long periods of time. And it also helps limit the amount of my subject's movement. You can create your own posing table. You can even use a couple of strong boards on wooden boxes, if you want. Just make sure the platform you create is steady under the weight of your subject. When you're photographing a subject on a posing table, take precautions to prevent the animal from falling off the edge; have a helper stand close by.

Other Helpful Equipment

I strongly recommend you always use a filter on any lens you may choose. A UV or an 81A filter is a good choice. It's a lot less costly to replace a scratched filter than it is to replace a scratched lens.

And you might want to consider a cable release for your camera. This allows you to be closer to your subject at the moment of exposure. It's something you might want to try, but it's certainly not something you absolutely have to have to become a successful photographer of canines.

Remember, equipment doesn't make the photographer. You don't have to have in your camera bag what I carry in mine. Take the ideas presented in *Creative Canine Photography* and other sources, apply them to your own situation, and you should become the type of photographer you want to be.

Treats and Licks:
How to Improve Your Learning

When I began photographing dogs, I made lots of mistakes. And I've already told you about some of them. You're probably reading this book because you want to make fewer and fewer mistakes as you pursue your interest in the photography of canines. In addition to sharing the advice and information about photographing canines put forward on these pages, I'm also going to share a few ideas with you about learning.

Early in my career, I kept notes of the various situations I photographed. I knew $^1/_{125}$ of a second shutter speed would stop the movement of this sitting Chihuahua's raised paw. The photo was shot on 400-speed color negative film with a medium-format camera using a 127mm short telephoto lens. The small shrub to the viewer's right creates natural framing for the subject, which adds a desirable compositional element.

Shoot Lots of Film and Take Lots of Notes

Shoot more film. Yes, take lots of pictures. The sheer volume of photographs you take contributes to learning. But only if you keep careful notes. Those notes will allow you to remember what you did, and—most importantly—they'll allow you to correct a mistake the next time you're making pictures.

Note taking, for the sake of learning, is serious business. Keep your notes in a notebook, not on loose scraps of paper. I like to use a notebook that fits into the back pocket of my pants. It just seems easier to pull it out, write something, and return it to that pocket again. You'll want to keep track of which lens and film you're using, the camera's settings for f-stop and shutter speed, and the lighting. If you're using a zoom lens, also make a note about the focal length at which it's set.

If you vary the processing from normal (push or pull), be sure to note that, too. If the photograph is "picture perfect," your notes will enable you to duplicate your results. If the photo needs correcting, your notes will indicate what you have to change the next time because those notes list all the pertinent details. Diagrams can help you remember lighting situations. This is especially true if you're using studio lights or multiple flash units.

If you do your own processing, be sure to include all that data in your notes, too. Include your choice of chemistry, time, temperature, whatever variables might be pertinent.

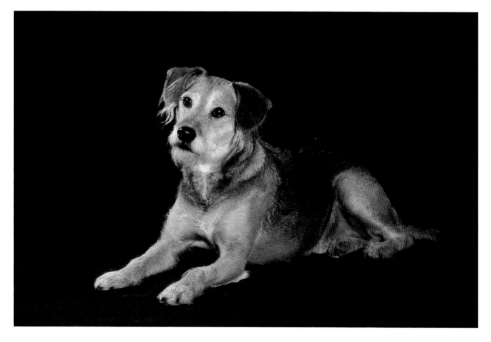

This alert, mixed-breed dog is named Jake. I'm lying on my stomach, using a 35mm SLR to capture this image. I used studio strobes to light him. Using a handheld flash meter, I set the strobe on the viewer's left at f/32 and the strobe next to the camera on the right at f/27. The camera settings were 1/125 of a second at f/32, but I found (using a snip test) that I needed to have the processing pushed one stop. I used a 70–210mm zoom lens set at about 180. The film used was Fuji Provia 400F.

Try New Things—and Read Film Packaging

Be willing to experiment a bit—try new techniques, new films. Just be sure you write about what you're doing in your notebook. When you do try different films, first read the information sheet packaged with the film by the manufacturer. You'll be surprised by all the important and helpful information that sheet contains. For instance, Kodak recommends an exposure of their Royal Gold 400 film of $\frac{1}{500}$ second at f/11 in bright or hazy sun, that is, when distinct shadows are showing. Their recommendations include circumstances like "cloudy bright," "home interiors at night," and more—even suggestions for circus photography. Remember, exposures of $\frac{1}{500}$ at f/11, $\frac{1}{250}$ at f/16, and $\frac{1}{125}$ at f/22 all allow the same amount of light through the lens onto the film in your camera.

By the way, you'll note the recommended camera settings for Royal Gold 400 color negative film and Kodak's Tri-X 400 black-and-white film are exactly the same. That is, $\frac{1}{30}$ second at f/2.8 for brightly lit home interiors at night, etc. The reason for this is that both films have ISO ratings of 400. In other words, both films have the same speed. There's a lot more solid information packed with film. Read it.

PAWS HERE

Three Rules of Thumb

Before you start cranking reams of film through your camera and taking pages of notes, absorb these simple rules of thumb. They'll save you having to learn them the "hard way." And, they'll help save you money on film and processing, too.

RULE OF THUMB NO. 1

Keep your thumb (and your fingers) away from the lens when you're snapping a picture. Seriously. You'd be surprised at how often a small portion of a finger or thumb shows up on the edge of a photo. Practice holding your camera correctly. It'll save you a lot of grief in the future.

RULE OF THUMB NO. 2

When exposing a subject that is backlit, open up two f-stops. For instance, change your settings from a bright-sunlight reading of 1/125 at f/22 to 1/125 at f/11. If your camera has auto exposure, set it on "shutter priority" or "manual" to achieve this change. It's always easier (and generally more accurate) to change the f-stop than to adjust the shutter speed. And there are important reasons why you shouldn't be photographing

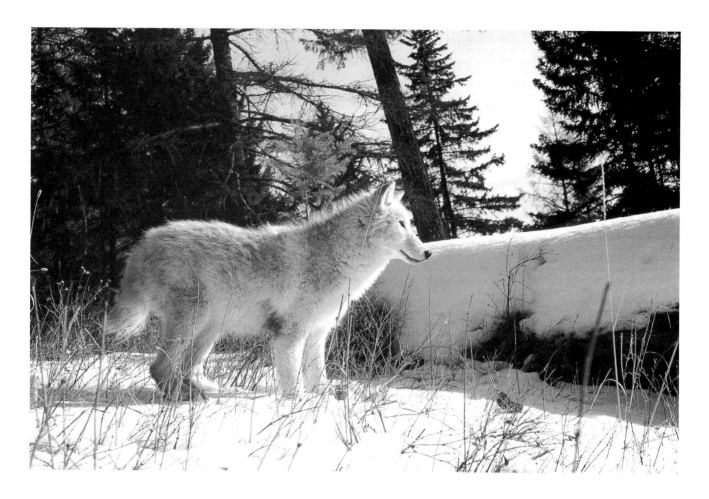

canines at slower than 1/125 of a second. My recommendation to you is to go out and test this advice. Right now. That's the best way for you to imprint this rule on your mind. And then you won't have to try to remember what to do the next time you come upon a gorgeously glowing, backlit canine. Your automatic memory should kick in to assist you to get it right. You might want to include the photographic results (a proof sheet) of this test in your notebook, along with the notes you made about that particular "shoot."

RULE OF THUMB NO. 3

Another rule to help simplify your photography of canines—shoot test rolls. Many professionals shoot tests on Polaroid film. That's a sixty-second test. If you don't have a Polaroid back for your camera, shoot a test roll. Set things up the way you want them, then shoot your film, noting variations in exposure, lighting, etc., and have the film processed. You can use a stuffed toy dog to simulate your live subject.

A contact sheet will help you read the results, and your written notes will help you

When you have the opportunity to photograph a backlit, gorgeously glowing canine, like this young Arctic wolf, open up the aperture by two f-stops. That way you'll capture plenty of detail in the animal's coat.

duplicate the desired results, or improve on them. This is just another way to ensure that you get the kind of results you want to create whenever you're photographing canines.

Once you get comfortable with photographing dogs, you won't need to make so many notes. But do keep track of variations from your "norm." These notes will help you whenever a similar variation comes up. My memory's good, but not perfect. I'm guessing that your memory is like mine. Write it down.

One of the big differences between a professional animal photographer and an amateur is the need to come back with usable, professional quality, photographs every time we work. There can be no "near misses" if we're to be successful professionals. Shooting lots of film, careful note taking, trying new films, knowing the rules of thumb, and test shooting will help you achieve the level of consistent results required of professional photographers.

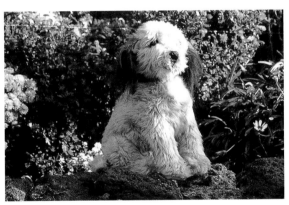

A stuffed toy dog makes a good subject for shooting tests. Remember to write down the details of each shot you make. Record keeping is imperative for successful testing.

 SECTION 2

Tech Stuff (Kinda)

I'm sure my suggestions back in section I will help you improve your photography of canines. Apply those ideas and practice the techniques I spelled out. You'll be glad you did. And here are more thoughts and additional technical information to help you control variables, choose your film, stop action, and light your subject in order to improve the appearance of coat texture in your photos of canines. 🐾

Terrier, Hound; Ears Up, Ears Down?: Learn How to Control the Variables

Your canine subject is more or less sitting where you want him to sit and stay. Maybe he's scratching somewhere that's very satisfying to him at the moment. But that's only now and then. In other words, your subject's ready for you. Are you ready to photograph him? Not yet!

You've got some decisions to make because there are several variables over which you have control. In this section I'll discuss films, shutter speeds, apertures, and more. I'll get you ready to make those decisions, to control the variables.

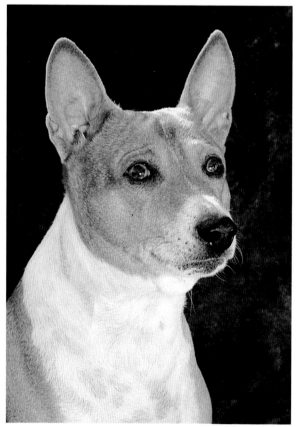

Get sunny highlights where you want them, like on the side of the face, or the top of the head, or the back of an ear, as shown on this Basenji's photograph.

Check the Background

First, where is this photogenic pooch sitting? Has he plopped himself down in bright sunlight? Is he a "junkyard dog" sitting in front of a rusted-out wreck of a car? And just what are you trying to say about this dog? Is it cute, or elegant? Does it guard, or just sit around the yard? Is it a lovable mutt, or a beautiful show dog? Well, you get the idea, right? You've got to make some decisions. And those decisions will help define the success of your next photographic adventure with this dog.

Check the Sun

A prominent and highly successful former *Life* magazine photographer once said to me, "The sun is a photographer's greatest enemy! I've been battling it all my working life." Yes, he said, "enemy." While the sun can add interesting and delightful highlights to a dog's coat, the sun can also bleach out the color and texture of that wonderful coat. It simply paints everything white, or at least light

 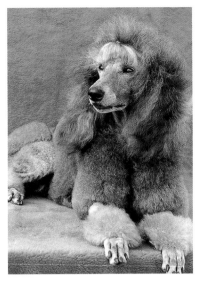 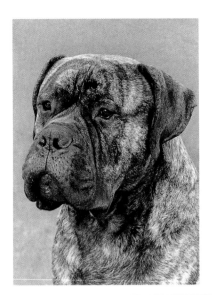

The mood of this pleasing photograph is one of solid companionship and contentment, while the technical execution is "right-on." It all adds up to a successful photographic effort.

gray. For both humane and photographic reasons, avoid placing your subject in direct sunlight. However, sunny highlights are a plus factor in your final photograph. While highlights result from your positioning of the subject, they can be created by either natural sunlight or by a secondary artificial light source (flash or studio strobe). Just make sure those highlights are where you want them.

Let's look at and analyze the photo below. The background is clean and uncluttered. There's a shadow area behind the dog's head. It's late afternoon, and sunlight is coming in low from the left, creating low contrast, so my wife and I got good detail in the shadow side of our subject's coat. We added a bit of fill flash to help light the dog's shadow areas. The dog's body is at a pleasing angle to the camera, and we have lowered the camera to look into the subject's eyes, which adds importance to the dog. The small bush on the left adds some framing to our composition. The subject's face is near the rule of thirds' upper-right cross-point (actually, his nose is just about on that intersection). My camera was on a tripod. The mixed-breed dog's coat contrasts with the natural setting.

LEFT TO RIGHT: What are you trying to convey about this dog? Is it as cute as a mixed-breed? . . . Or is it as *Dog-World*-cover-dog elegant as this Standard Poodle? . . . Does it guard like a stern and serious Bullmastiff? . . . Or is this dog just a lovable mutt who sits around the yard? . . . Or show-dog-beautiful, like a Shih Tzu?

You might find it easier to control the placement of highlights on a dog by changing your camera position, rather than by trying to reposition the subject. Walk around your canine model, and look carefully at how the sunlight changes on him. Also, carefully note the changes in the background as you explore possibilities.

Hazy, overcast days are good days for photography outdoors. Your dog will be more comfortable (no dripping tongue hanging out and no squinting eyes); you'll get better color saturation in the dog's coat, too; and you'll not have to deal with harsh shadows. It'll also be easier for you to get the correct exposure on a hazy day, as well. You'll still get directional light, however. Remember to place your subject so the light's direction is from the side or from the back.

How to Avoid Hard Shadows

When I'm in the field photographing wild animals, I avoid making pictures in the middle of the day (generally from 10:00 A.M. to 2:00 or 3:00 P.M.). I'm avoiding harsh light, hard shadows, and high-contrast lighting, all of which occur then. Harsh light and high-contrast lighting reduce color saturation in the shadow areas and blow out details in the highlights. I strongly suggest you wait for the light that'll help you create the best possible tail-waggin'-good photographs. You can expect good light early in the morning and late in the afternoon, when the sun is low in the sky. This low-angle light creates interesting shadows in your photographs. Because the sun is less intense early and late in the day, the shadows created at these times are softer, too. There's even a

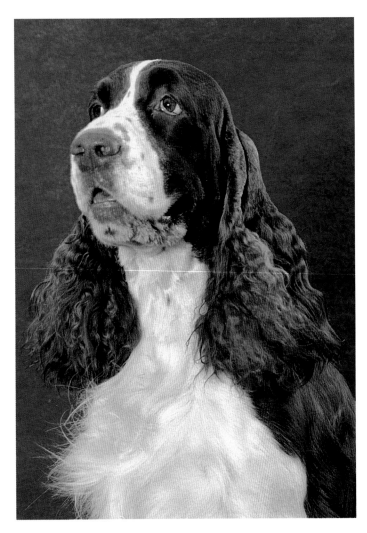

final light at the end of the day that adds warmth and texture that's only possible for a few, short moments. Photographers sometimes call it that "golden moment" because it does add a golden hue to the photographs made at that time of day.

Work Indoors, Too

You can photograph indoors as well. Today's high-speed films will give you excellent exposures, often without flash. For example, using film with an ISO (also referred to as "ASA") rating of 400, you could photograph your dog near a window with sunlight streaming through it at 1/125 of a second at f/8. These settings will vary with the color of the dog's coat and the distance you place the dog from the light source (the window). But, no matter what color coat your dog wears, it's possible to create indoor portraits without flash.

Check Your Perspective

Now, let's look beyond your subject and see just what's behind that dog. If you're standing and pointing your camera down at a small subject— say, a Pomeranian or any very young puppy—the background is most likely grass or concrete. If the dog remains still, but you get down on your knees, the background might become a combination of shrubs and grass. If you lie down on your belly, the background might now become sky, or bushes and sky, even though the subject is still in the same place. And, if you raise the dog—placing it on a low wall or table, for instance—while you remain low on the ground, then the background will probably be only sky, with maybe some clouds adding interest to it. By the way, whenever you place a dog on something to photograph it, make sure that that platform provides a very stable base—no wobble! Otherwise, the only expression you'll get from your subject is one that clearly states, "I'm worried."

The camera angle you choose is called photographic perspective. The dictionary defines perspective as "a technique of depicting spatial relationships on a flat surface, and the state of existing in space before your eye." The

This English Springer Spaniel was photographed on an overcast day. The dog is comfortable, and there are no harsh shadows to fight photographically. Notice there is some directional light from the viewer's right. Yes, I do sometimes use cloth backdrops outdoors, as I've done here. Note that it's important to make sure there is some fur entirely outlining the "far" eye (the dog's right eye in this pose).

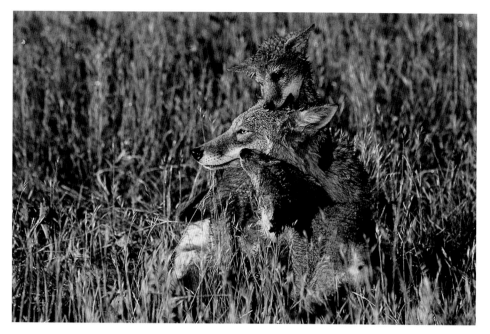

This prize-winning photo of a coyote parent with pups was taken early in the morning. The lighting is interesting and directional; the shadows have lots of detail in them. Note that the two pups' heads (above and below the adult's) are on or near the cross-points of the rule of thirds imaginary lines. I'm on my knees, with my camera on a tripod, behind some rocks. Notice, too, the adult coyote, looking toward our left, has plenty of room to look within the photo. That adds to the sense of capturing something as it happens: life.

photographs on page 40 are an easy comparison of the role of photographic perspective using just two photos of a Pomeranian. In photo A, the camera is pointed downward at the subject. In photo B, the camera has been lowered to point slightly upward at the dog. I think photo B is more pleasing to the viewer, and the dog is more important to the overall photograph in this second shot. My notes tell me photo A was taken at 1/90 of a second at f/6.7 (that's halfway between f/5.6 and f/8), using a white reflector to bounce some

This **Soft-Coated Wheaten Terrier** was photographed indoors—actually, in his person's office. Windows to the viewer's left streamed light across that unusual full coat. Fill flash at one f-stop less than the window lighting measured completed the set up. The print film was Kodacolor 400.

B

A

light into the shadow areas on the dog. Photo B was shot at 1/125 at f/5.6, using a gold reflector for fill. I used ISO 100-speed film—with no flash, although my subject was in shade. Don't be fooled, the dog is in shade, even though the sun shines on the grass and bushes behind the dog.

Photographically, your subject will appear more important if you lower your camera at least to the level of the dog's eyes. The lower your camera is (the lower the photographic perspective is), the more impact or importance your subject will have in the resulting photograph.

Again, perspective must also be considered when looking beyond your subject, at the background of your image. Are there objects seemingly "growing" out of your subject? Because a photograph is a two-dimensional image, things like trees and poles in the background can appear to be literally rising up out of your subject. When choosing your photographic perspective, look at the background, as well as at your canine subject. Either move your camera (change your perspective), move your dog to eliminate any problems, or throw

the background out-of-focus. More on this way to remove distractions is coming up later.

First Impressions are Important

While you're looking through the lens at your subject and the background, also note what a viewer—looking at the photograph you're about to create—will see first. Will this first impression create the feeling you want the viewer to get? Are you creating a cliché (that's okay, if that is what you're trying to create) or a new, fresh look at the canine subject you're photographing? Have you included only those elements in the photograph that contribute to the image you're trying to create? Clean up the background and foreground. Physically remove any trash or unwanted debris. Yes, pick it up. Things that don't belong in the scene always distract from your subject. Yup, there are lots of decisions to be made, but these variables are all under your control.

Create a Composition

And there are a few more things for you to consider, like the composition of your photograph. To get a more dynamic, harmonious, and pleasing photograph, place your subject off-center. Mentally divide your photo, both

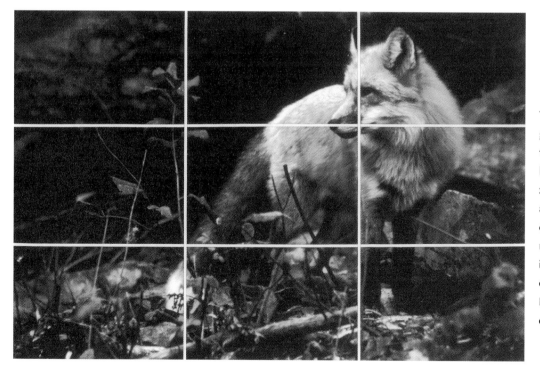

The lines on this photograph of a red fox divide the photo into thirds, both vertically and horizontally. The four points at which these lines cross indicate where the maximum visual impact is located. That's the rule of thirds at work. Gee, I wish I'd raised my camera just a tiny bit.

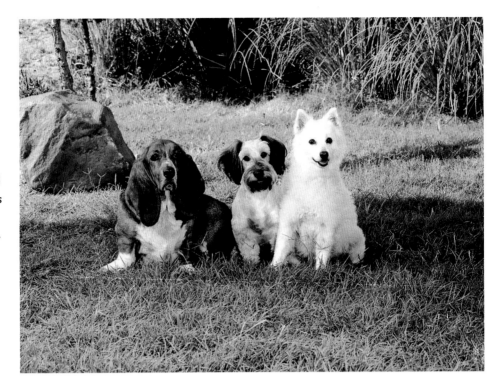

This pair of photographs of a trio of dogs clearly illustrates the need to eliminate unnecessary elements from your photos. Actually, these two prints are from the same negative. I simply cropped closer to the canine subjects to clean up—and improve—the bottom photo.

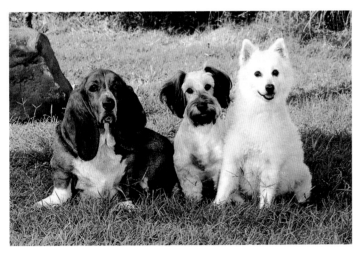

horizontally and vertically, into thirds with make-believe lines. Sort of a tic-tac-toe layout. Naturally, this is called the rule of thirds. Each intersection of the vertical and horizontal lines—the four cross-points where those lines meet—is a point of maximum visual impact in your photo. And it's at one of these four cross-points (or very near them) that you want to place the eyes of your subject, or any other center of photographic interest you may have created.

If there's more than one subject, try to place each subject at one of these cross-points. This type of composition gives your photo a feeling of life, or motion. It leaves space in your photograph for the dog to move into (if it was about to move). And it probably will move into that space right after you snap the shutter, unless you've restricted it in some way, like placing it on a posing table.

Precise composition absolutely requires you to use a tripod or other device to hold your camera steady. I also use a tripod whenever I'm photographing coyotes, foxes, and wolves in the wild.

Importantly, using the rule of thirds composition will give your final pho-

tograph an additional plus. Use these imaginary lines to help you strike a creative balance between foreground, subject, and background. This helps you avoid the static and undesirable image of a horizon line visually cutting your photo in half, creating an even balance between foreground and background. Make sure your canine subject fills one-third or more of the photograph. Please remember, only include elements in your photos that actually contribute to the photographic image you're trying to create. Yes, we're back to that pre-planning we talked about.

"Read" Your Composition

While we are talking about composition, let's look at something called "leading lines." All photographs have lines, actual or implied. And our eyes tend to follow those lines when we're looking at pictures. They can be diagonal, straight, or curved. Good photographers take advantage of them. Diagonal lines suggest action. Straight lines can lead us into the distance, provide strength and stability when vertical, or convey calm and peacefulness when horizontal. A curved line in an S shape is feminine and graceful; in a C shape, a curved line suggests power. Oh, yes, in the Western world, we "read" photographs as we do our written or printed language—left to right. Generally speaking, the animal subject will dominate the photograph you create. That canine is your photo's "center of interest." It should hold the viewer's eye, create a mood, and define that individual dog.

The importance of understanding the viewer's eye movement, which coincides with the way we read, is demonstrated by this flopped image (left turned to right) of the photo that appears on page 139. Notice how the Poodle is facing toward the viewer's right, the opposite direction our eyes take as we read the image from left to right. Take advantage of this knowledge as you compose an image by considering what will be the viewer's eye movement. Do not arbitrarily flop a processed photograph, however, because the image just won't look correct to the dog's people. Of course, if the dog has distinctive color patterns in its coat, you'd never even consider flopping it. Instead, make such decisions before you click the shutter.

For the purposes of demonstrating my point, the more ideally composed image on page 139 is flopped (left-to-right) here, to the photograph's detriment.

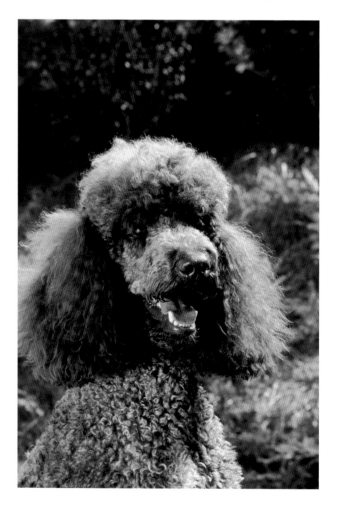

Your subject will probably dictate to you whether you create a vertical or horizontal image, as did this mixed-breed dog.

Also, if there are any secondary elements in your photograph, they must not be so strong that they prevent the viewer's eye from returning readily to the center of interest—the dog. Most likely, you'll be able to achieve this if you move in tight to your subject, whether you're doing a head-and-chest or a full-body portrait. Keep it simple. Whichever orientation you use, remember to keep your camera level. Just look at the edges of your frame to make sure you've positioned your camera properly. While you're looking at those edges, eliminate any empty areas or distracting objects that appear there. This will give your photograph maximum impact, impact like a dog's wet tongue slurped across your face.

Posing problems multiply exponentially when the number of subjects increases. It's a lot more difficult to get four subjects in a pleasing arrangement than it is to pose only one. Think in terms of triangles—one dog's face at (or near) each point, for instance. If you're photographing more than three subjects, let the triangles and your subjects touch or overlap. Arranging a group of subjects strongly suggests the need for a partner or assistant. It could be your spouse (as in my case, my wife, June) or it could be the dog's companion person. Practice with your helper. And be ready to snap the shutter at the instant your subjects look at, or react to, that attention-getting device. Anticipate the moment.

These suggestions are not "carved-in-stone" rules. Think of them more like your dog's favorite chew toy. As the dog chews on the piece of rawhide, its shape changes subtly, or maybe even dramatically, but it's still a chew toy. Eventually, your dog will master it. So, too, will you master these compositional elements as you use them, first to visualize, then to create, wonderful and pleasing photographs of canines.

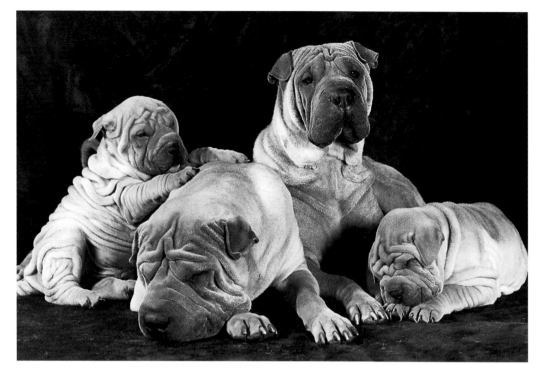

Even if your subjects don't cooperate, you can still capture some very appealing moments, as I did with this Shar-Pei family. Note that the photo is composed of two conjoined triangles (the one on the left is upside-down).

Control Color Balance

Consider color balance, too, if you're working with color film. You've got two basic choices: contrast the background with the color of the dog's coat, or blend the background color with one of the tones found in the coat of the dog. Look at the examples throughout this book. I've used both approaches. You decide what you like best. It's your decision. Make it work to enhance each photograph you're creating.

Create a Story, Mood, or Emotion

Tell a story with your photograph, if you can. That story might be one of mood or emotion, or one of action. Will the viewer of your photograph say, "Awwww," or, "Wow," or, "Cool," or maybe just chuckle a bit?

To help you create the story you want to tell, I've probably listed more variables than you thought possible. But they are there, and you should consciously make decisions about all of them, just as you make carefully thought-out decisions about the film, shutter speed, and aperture you use. We'll talk about those things next as we continue our walk toward that fire-hydrant-perfect-when-your-dog-needs-to-go photo.

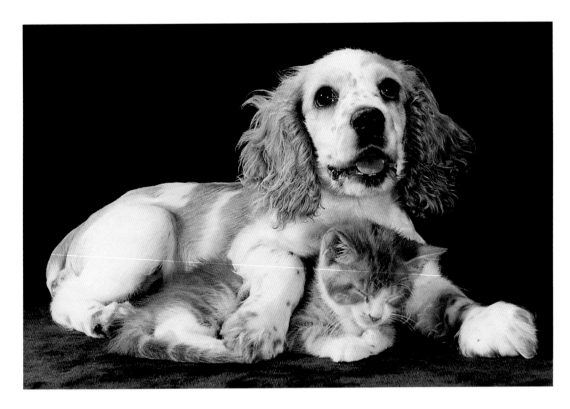

This pair of cute animals appeared on billboards, under the caption, "Bo got adopted today. I didn't." The humane societies that used it got tremendous results from this ad because it effectively tells a story and creates a mood. Which one do you think is Bo?

PAWS HERE

Check List for Total Photographic Control

Answer these questions, and you'll be well on your way to creating a photograph of which you'll be proud.

- Is the background appropriate?
- What's the position of the sun?
- Does the lighting provide detail in the shadow areas?
- Are you using the correct film for the lighting?
- Is this the best perspective?
- How's the impact—what's the first impression?
- Are you using the rule of thirds?
- How does the photo "read"?
- Are the edges of the photo clean?
- Is there good color balance?
- Does it tell a story, create a mood?

About Films: Prints or Slides?

Do you want large photos of your dog that you can frame and hang on the wall or stand on top of the piano? Or do you want photographic prints of "Fabulous Fido" that you can put into an album or show to your friends and family? For both of these end results, you'll want to use print film (it's also called negative film) in your camera. However, if you want to put together slide shows of your favorite canine at home, on vacation, and in the park, you'll choose slide film (also called reversal film, transparency film, or chrome). But you'll need a projector or some other type of special viewer to see those dog-gone good slides you've created. Many point-and-shoot or compact cameras don't give very good results with slide film, but they can produce satisfying photographs using print film.

When to Use Slide Film

As a professional animal photographer, the vast majority of the images I create today are on slide film. That's the kind of film editors and publishers have asked me to use over the years, though now publishing companies seem to be able to reproduce pretty well from prints, too. Film choice hasn't really been mine. I simply serve the requirements of my customers and clients, who generally believe slides are sharper and reproduce best when the final color images are being printed in magazines, books, calendars, and other places where my photos appear.

Color slide film produces transparent positive images that really look like the original subject. It produces a greater range of tones than is possible on paper. Almost all of the color photographs shown in this book were reproduced from 35mm slides, though some of those slides were duplicates made by my lab from original negatives. You cannot readily alter the image once slide film is developed, except through the use of computers and digital imaging. This limitation makes slide films very unforgiving of any errors the photographer might make. And, believe me, professional photographers, like all others, do make mistakes. But we also learn quickly how to correct many of them. Exposures must be correct—read that as "exact"—when you're working with slide films.

When to Choose Print Film

When I'm creating wall art portraits, I choose print film. For years I used Kodacolor 400 print film, and I created hundreds of prints, ranging in size from 16" × 20" up to 40" × 60", from medium-format (2¼" × 2¾") negatives. These were prints without grain, mind you, when many professionals mistakenly believed that no one could create prints that good and that large from a 400-speed film. While automated printing equipment can give you high-quality prints quickly, custom printing will give you even better enlargements.

Today's excellent print films are flexible, forgiving. They accommodate a wide latitude of exposures (you can make a mistake in exposure up to four

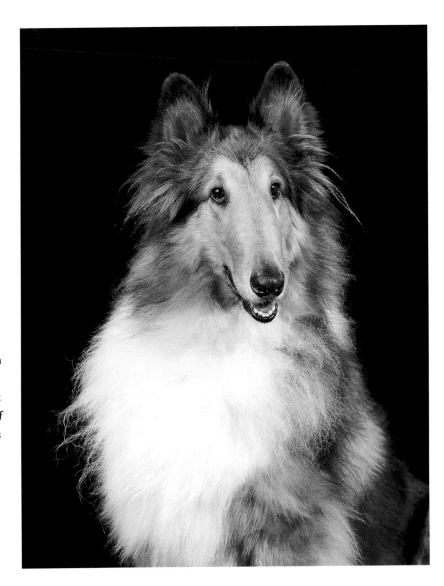

A leading company used this photograph of a Collie as a greeting card, even though the depth of field was less than ideal. Notice that his eyes and ears are sharp, but not the tip of his nose. Lovable expressions can sometimes overcome photographic shortcomings.

stops over or two stops under, and still get acceptable prints). And you can use mixed lighting sources. They'll give you superb grain and sharpness, even in the 400- to 800-speed range. They record a wide range of tones. Print films do record a truly great amount of information. Oh, yes, negatives provide a full information medium and can be scanned and printed digitally, too. You can even have your negatives stored on a disk when you get your processing done. And you can make all kinds of adjustments when prints are being made from negatives.

The photograph of that handsome young Afghan Hound on the cover of this book was originally shot on 400-speed print film (2¼" × 2¾", or 6cm × 7cm format). It was then cropped a little and copied on 4" × 5" transparency film by my talented friends at the commercial photo lab I depend on for so much.

Some Print Film Tips

Here's a simple tip about working with print film: when in doubt about exposure, overexpose! There's no need for us to get into the chemistry for this, but print films are created to prevent over-development of highlight areas. Expose for shadow detail. You can do this by using a spotmeter to read the light in a shadow area on your subject, or by moving in close with your center-weighted meter and reading it on a darker (shadow) portion of your subject. If you want to put your camera on automatic, then you can set your camera for ISO 200 film when you're actually using 400-speed film, or 400 when you're shooting 800-speed. The Kodak "Versatility" film used in point-and-shoot cameras actually does that for you. Those films are faster than they are rated.

Underexposure of print film, on the other hand (paw?), is very serious! While print films are tolerant of some underexposure, they fail beyond a two-f-stop mistake. They can turn to a brown muddy look, get grainy, and lose their snap when badly underexposed. Print films can be pushed, if you make a mistake and seriously underexpose them, but you'll need to find a custom lab to do that kind of processing for you.

If your dog happens to chew one of your favorite photos, remember that print film can help you quickly replace that destroyed photograph because you still have the negative. Just be sure to store your negatives properly.

Only one size of film will fit your camera—probably 35mm—but many different film types and speeds will work in most cameras. Your camera's instruction manual or information sheet will tell you what the manufacturer recommends as best. By the way, let me remind you to take the time to read the instructions packed with your camera. You'll be surprised how many of the problems you're having can be resolved by following those instructions.

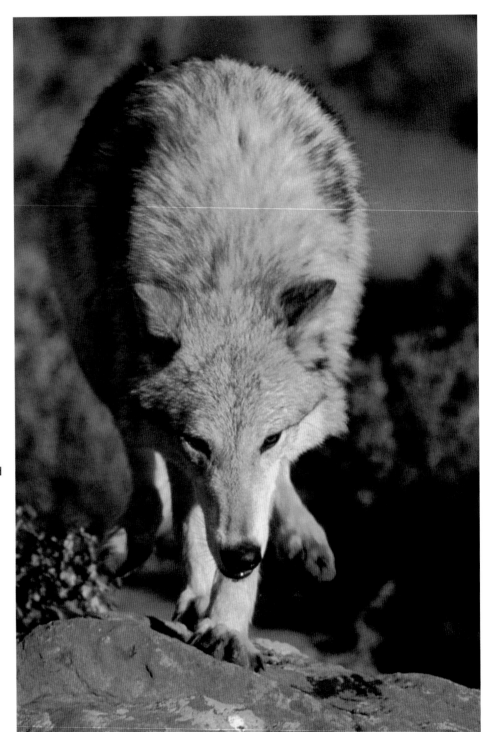

This gray wolf was photographed in early morning on Fuji Provia 400F film. Notice the film captured fully saturated color and provided fine grain, reproducing all the detail of the wolf's coat, just as I saw it.

Some Film Choices

Print film can be found in color or black-and-white. Slide film is almost always color, but there is a black-and-white slide film, Agfa Scala 200X. Film speed is measured in ISO numbers, clearly marked on film packages. Generally, films with a 100- or 200-speed ISO may be used outdoors on a sunny day, or on bright days (lightly overcast, but with definite shadows), or with flash indoors. However, many scenic photographers choose Fujichrome Velvia, a film rated at an ISO of 50 by its manufacturer, though some photographers choose to rate it at EI 40. While photographers cannot change the International Standards Organization's (ISO) rating of a film, they can change a film's Exposure Index (EI) to suit that photographer's use of a film. Velvia is used extensively because of this particular film's ability to record saturated colors in subtle variations and to produce rich blacks and neutral gray tones. Velvia Professional slide film with an ISO of 100 is also available now. Print films, though very good, cannot match the saturated colors produced by slide films like Velvia or Kodak E100VS (recently replaced with E100G, and a "warmer" version, E100GX).

But those relatively slow films are not good choices for moving animals, or doggie portraits, which, in my experience, require shutter speeds of at least 1/125 of a second and a somewhat greater depth of field. Manufacturers recommend the use of 400-speed film when you need a fast shutter speed for action outdoors or for indoor photography without flash. I recommend 400-speed film for all your canine photography. This allows increased depth of field, which is very important, especially in canine portraiture, while maintaining a movement-stopping shutter speed of at least 1/125 of a second. And I strongly suggest that you stick with print film, until you're ready to begin marketing your photos for publication or you have another specific reason to switch to slide film.

My earliest efforts to photograph my own Pembroke Welsh Corgi, Harmony, resulted in softly focused nose and ears, even though her eyes were sharply focused. I knew I had to figure out something about increasing my depth of field, to get ears, eyes, and the tip of her nose all in sharp focus, while maintaining a shutter speed which would stop Harmony's normal movement. Yes, Corgis do have long noses. And if I'd had a snub-nosed Boston Terrier, perhaps it would have taken me a lot longer to learn this lesson. But it was from that experience with my own Corgi that I learned why depth of field is more important in animal photography than it is in photographing people. Just take a look at the comparatively short distance from the tip of your own nose to the tops of your ears. Contrast that distance on your face with the distance from a Collie's nose to its ear tips. Now you understand what that difference is. More on depth of field in chapter 9.

Ektachrome E-200 film captures whites beautifully, as this photo of an Arctic fox in the snow on a sunless day clearly demonstrates.

More Films to Consider

Fuji makes Press 400 and Superia 400 print films and Provia 400F slide film, which all work well for animals. I've done an extensive amount of work with the Provia films, both 100F and 400F, which I believe give me natural-looking images with excellent color rendition and contrast. Both can be push-processed one stop with almost no change in the quality of the image. Kodak's Ektachrome E-200 slide film can also be push-processed to 400-speed with good results. By the way, Fujichrome Sensia 400 delivers almost the same results as Provia 400F at less cost. It doesn't get the same carefully controlled handling that Provia gets, and therefore costs less.

Portra Professional 400VC and Supra 800 print films, both from Kodak, work well for fur, as does Fujicolor Superia X-TRA 400 (by the way, 96 percent of the photographic film sold throughout the world is color print film. If print film is your choice, you're certainly not alone). We're in an era of new films being continuously introduced by manufacturers. Experiment. Try various films until you find the one that works best for your subjects. But, please,

Whoops! I underexposed this common gray fox's photo. A snip test showed me I missed by 1/3 f-stop. In transparency film (which I was using here), even as little as a 1/3 f-stop error can wreck the photo. The lab push-processed my film, effectively bringing the film exposure back to the correct one. You see those corrected results here.

remain open-minded and continue to try using new films that might be introduced from time to time.

Don't rely on "portrait" films for your canine portraits, since those films are usually color-balanced for skin tones. It's not a "modesty thing," but most of the dogs you're photographing will show you very little skin.

Want Large Prints?

I've successfully produced top-quality fine art prints (up to 23" × 35") from 35mm film (from both negatives and slides) using drum scans and dot-matrix printing. This type of imaging is now widely available. And, as I mentioned

earlier, I regularly produce 16" × 20", and larger, fine art prints from 35mm slides using normal optical reproduction. For larger prints like these, I recommend you avoid digital images and stick to film as your imaging source. Maybe later, things will change.

As you work with various films, you'll discover what each film will, and will not, do under different circumstances. Stick with what works best for you, but be willing to try new products as you learn about them, too. Read magazines and books to help keep yourself informed about new products as they are introduced.

Choices of Processing

If you want to learn to do your own processing and printing, there are many fine books available to help you get started and to assist you in perfecting this part of your photographic art. It'll be easier if you start with black and white processing and printing, then move on to color, if you so desire.

I happen to choose to use a professional lab for all my processing. I don't have the time in my shooting schedule, nor do I have the personal desire, to do darkroom work. That doesn't mean you shouldn't do your own processing and printing if you enjoy it. I've certainly done plenty of that kind of work over the years, and that background experience helps me in working with my lab today. I just don't want to spend my time in the darkroom now.

When I first began producing 16" × 20" prints for customers and print competitions, I sought out a highly respected professional lab. I observed print quality in competitions at my local professional photographers' association (Professional Photographers of America affiliate), where 16" × 20"s were required, and I talked with other professionals. After that kind of research, I felt comfortable working with the lab I chose. And I won the first local professional competition I entered.

By working with the same materials and the same lab for some time, I know what to expect from both. And I know when and how to deviate from "the norm" when it's required in order for me to create something specific that I want. Sometimes, a change in processing just helps to save my shot. When photographing animals, especially in the wild, it's not uncommon to underexpose or overexpose a subject. You can discover these exposure errors by doing a "snip test." And the error can be compensated for (within limits) by either push- or pull-processing your film.

Here's the way it works. If you suspect you've made an exposure error, ask your lab to do a snip test. They cut off about three frames of film from the end (either front or back, you can request either one), and process it normally. You, or a technician from the lab, then look at that short piece of your film to

see if it looks correctly exposed. If not, an adjustment in processing the remainder of that roll of film can compensate for your error. If the film was underexposed, the remaining film will be push-processed. If the error was overexposure, then pull-processing will help compensate.

PAWS HERE

Checklist for Film Use

Here's a checklist of a few things you can do to improve the results you get from any film:

- Store film in a refrigerator. Let it reach room temperature in its canister or packaging before using it. This takes about one hour.
- Use film before the expiration date imprinted on it.
- Process film as soon as possible after exposing it.
- Load your camera (and unload it) in soft light or shade—avoid direct sunlight.
- Keep film (and loaded cameras) out of hot, humid conditions. Do not leave film in closed cars (especially not in the trunk or glove box).
- Use "pro" films, which cost more, if you want to be sure the film you use has had the most proper handling before it gets to you.
- When you travel with film, never transport it in luggage checked on an airline.

CHAPTER 8

Stopping Motion: Subjects and Shutter Speeds

"**H**ow do you get animals to sit still for pictures?" That's one of the first questions I'm regularly asked by photographers wishing to improve their photography of dogs.

I could suggest they learn witchcraft. But I usually just tell them to do something specific to get the dog's attention. That is, make a sound or a movement at the moment of exposure. After all, you only need to arrest the subject's movement for a fraction of a second, perhaps for as little as 1/125 of a second. That's not really having to "sit still," is it?

Use Noisemakers

One thing I learned early on: A dog is likely to react to a sound, or to a fluttering handkerchief, or to a thrown cap, only a couple of times. Then you've got to bring out something new and different. Over the years, I've used slide whistles, metal clickers, electronic sound makers, party favors that unroll when you blow into them, shepherd's whistles, squeak toys, even baby rattles. I carry them all in a bag. I also make noises with my mouth—puppy whines, kitten meows, whistling, and other odd sounds. The high-pitched, puppy-whine sound or a "wolf howl" will often elicit a cocked head, a curious or quizzical pose. If one sound doesn't create the response I want, I move on to another. Your subject will look at the site of the movement or source of the sound, so place your helper who's making the sound where you want your canine subject to look. And stay in control of these efforts to direct your subject's attention. Allow only one person to make one sound or movement at a time. Otherwise, your canine subject literally won't know where to turn. And neither will you!

The dog's owner (if it's not your pet pooch) can tell you if the dog responds to any specific phrases. One owner, whose dog we were photographing in his own backyard, asked his dog, "Where's the kitty?" You should have seen the wonderful, intense expression that question elicited from that

dog. But the dog was looking around, moving his head almost frantically as he tried to see the cat. Other phrases I've seen work often are, "Get your bone!" and "Where's your ball?" Your subject might respond to others. Ask. Then use those phrases.

A note of warning: keep the noise levels down. You want to intrigue your subject, not scare it. Be subtle. I'm sure you've observed your own dog raise its head from a sound sleep to listen intently to something it heard, but you heard nothing at all! This clearly demonstrates that a dog's sense of hearing is much sharper than is a human's, so keep your attention-getting noises low-key. Sounds do play an important part in a dog's life. That keen sense of hearing is their nature, part of their defense system.

Move Around

I like to vary the direction my subject's looking, so I have my helper move from the camera to the right of the camera, to the left of the camera, above the camera, and below the camera for variation. This can create the need for some pretty funny contortions by your helper, but we'll try anything to get that special photograph! Hopefully, your helper will be just as willing to make a fool of himself or herself, as is my wife, June. I make the attention-getting sound when I want my subject to look directly into the camera. If you want

This Bulldog puppy was fascinated by the bubbles my wife and helper, June, who was lying on her back on the ground in front of the posing table, was blowing toward him.

This mixed-breed pup played with his new rawhide bone, until he did what puppies do so well. He took a nap. Make sure any objects included in your photos look decent. No chewed up or half-consumed bones, please.

your canine subject to look beyond the camera, toss something (like a film canister with a couple of pennies in it) over your shoulder. Another animal may be used to attract a subject's attention, too. With small breeds, you can have your helper simply carry the other dog, or cat, in and hold it where you want the subject to look. With larger dogs, walk them in on a leash. Just use good common sense about maintaining the safety of both animals—keep them under full control—for humane, as well as photographic, reasons. Remember, no photograph is worth traumatizing any animal. Also, understand that some dogs might get frightened by new toys or unknown objects coming toward them. Move them slowly.

Or you might simply show your subject that special ball or other favorite toy. Just remember, don't get the dog so excited that it runs around looking for, or trying to do, whatever it has been asked. You want the response to come on the face, eyes intense, perhaps the ears up. But you want the subject to remain where you've placed him.

Until you and your assistant get used to each other, count out loud, "one-two-three," for the sound or movement to be made. That way, you'll be able to anticipate when you'll be getting a response, and snap the shutter at the instant of the subject's reaction.

Owner as Helper?

The dog's owner/companion could help calm and reassure the dog while assisting you in your photography. But be aware that a dog's "person" sometimes has the opposite effect on the animal. If the person is uptight about the photo session, wanting desperately to make everything come out all right and to have his "pride and joy" perform perfectly for the photographer, the dog probably will be uptight, too. If that happens, be prepared to provide your own assistant.

And speaking of pride and joy, one subject's companion person discovered his photo on a greeting card display in her grocery store (see the photo on page 48). She bought them all. As she was paying her bill at the checkout, she commented to the clerk that the dog in the photo was her dog. The clerk's

Hand-holding a reluctant Great Dane won't prevent getting a good portrait. Just keep the human arm and hand out of the final print.

This tiny Bichon Frise stayed perfectly still for its photo when we sat it on an overturned decorative wastebasket in the living room of its home.

response was, "Oh, you've got a dog like that?" The woman replied, "No, that is my dog!" The clerk didn't understand. She was convinced it was simply a look-alike. Only someone who lives with a dog will understand the pride their canine "joy" can bring to them.

Take advantage of that pride. You might ask the dog's owner to bring some of the dog's favorite treats to your photo session. This is an excellent way to provoke an interested expression. Even just showing the dog the treat will often capture his attention. You don't always have to feed it. At dog shows, you often see handlers use a bit of liver to get their dogs to look up at them while the dogs are posing prettily for the judges. Only occasionally do the handlers actually feed a tiny piece of liver to their dogs. That works for canine photography as well. Hot dogs that have been cut into small bite-size pieces work well, too. Keep the tidbits small, so you don't lose a lot of valuable time waiting for your subject to chew and swallow that reward. And watch out for fallen crumbs, which can spoil a shot.

Try Physical Restraint

And finally, if all else fails to keep your subject sitting where you want it to sit, have someone (the owner?) hold the dog's hindquarters to keep it in place. You can still get a good head-and-chest portrait this way, by eliminating from your final photographic print the part of the body being held.

Look carefully through your viewfinder for any "offending" human fingers. Crop them out in the viewfinder. With sitting dogs, one hand firmly placed on one thigh should accomplish this. Caution: make sure your assistant's shadow doesn't fall across the dog—or at least that part of the dog you are photographing.

Another way to restrict a subject's movement is to place it in something, like a basket, or on something, which will stop it moving too much because of these simple restraints. More details on this technique are coming up in chapter 10.

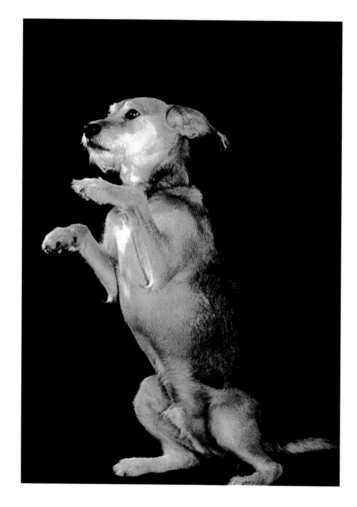

A shutter speed of 1/125 stopped the action of this mixed-breed sitting up. Of course, the duration of the flash was even less than 1/125.

Tips on Shutter Speeds

On the technical side, set your adjustable camera to a shutter speed of 1/125 of a second. This will stop most movement of a sitting or standing canine (remember, you've arrested the dog's attention with noise or some other attention-getting device you or your helper used). Or, set your camera at 1/250 to completely eliminate any blur from paw or head movement in this same situation. The use of electronic flash as your primary light source should also stop movement, no matter at what speed your camera is synced to that flash, since the flash is on for such a short duration of time.

Action photos, such as a running canine, usually need 1/500 of a second or faster shutter speed to freeze the action. Again, films with an ISO of 400 or faster are absolutely necessary for success here. If your camera isn't fully adjustable like mine, you might try using a technique called panning, which could help you photograph that action.

In my opinion, a little blur around feet or paws is generally not a problem, as long as the head and body of the subject have been stopped and are sharp. That bit of blur depicts action to the viewer. And it proves you're not photographing a stuffed animal. It's easier for you to stop action when your subject is moving either directly towards or directly away from your camera, when a shutter speed of 1/250 of a second should catch the action for you.

So, you can see, there are lots of ways you can stop the dog's motion long enough for you to capture a most appealing photograph. Now all you have to do is perfect your timing. Practice.

ON THE WILD SIDE

Yes, panning your camera helps capture a running dog's photo, too. You track the moving dog in your camera's viewfinder, moving the camera at the same speed as the dog is running. While you move the camera to follow the dog, you press the shutter release. Begin panning before you snap the shutter, and follow through, continuing to follow your subject after you've clicked the shutter. Successful panning requires some practice, but it allows you to create wonderful action photos at less than action-freezing shutter speeds. An additional, and positive, result of using the panning technique is that the background of the photo becomes blurred when you pan your camera, though you may get lines in the background. Using a tripod is almost a "must" when panning. Special panning heads are available for tripods. A tripod-mounted camera will assist you in avoiding vertical lines created by an improper up-and-down motion of your camera while panning.

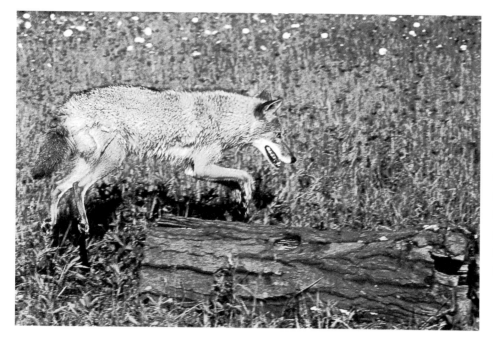

This cavorting coyote's pounce was caught in mid-air using a shutter speed of 1/500 second. Spontaneous action creates wonderful canine photographs, no matter whether the subject is wild or domestic. Be ready.

Using the technique of panning, I was able to take this action photo at 1/90 of a second at f/11 with off-camera fill flash set at −1 f-stop on ISO 200-speed film. Notice the background is quite blurred from my moving the camera to follow the little Pomeranian. The short duration of the flash, and the shutter speed, pretty much stopped his movement as he ran across in front of me.

Smooth Coat, Longhaired, or Wirehaired: Lighting for Texture and Selecting Apertures

As you know, the content and mood of any photograph can be changed dramatically by changing the direction of the light source. Study light. It's your major tool—not your camera, not your lens, and not your film. Light.

Lighting can be direct, diffused, or reflected. The source can be the sun, a studio strobe, or a flash unit. Direct light illuminates your subject from the source directly, without anything between the source and the subject. Diffused light passes through some type of translucent material, such as a scrim, which could be simply a piece of fabric; a tent; plastic; an umbrella; or a softbox. To diffuse the sun, I often use a large piece of white sailcloth, which I had fashioned by a sail maker.

Reflected light is bounced off something—a wall, an umbrella, or a piece of cardboard or reflective fabric—onto the subject. Reflected light softens light the most, but as the main light for animal photography it reduces coat definition too much. Therefore, it's not as useful as the other two types of lighting for our purposes.

Measuring Light

Two kinds of light meters can be used to measure light. Your camera might have one built in. If it does, this is a reflective meter. It measures the amount of light being reflected by your subject—including what you've framed your subject with (foreground, background, and both sides). The other type of light meter is called an incident meter. It has a little dome, is handheld, and measures the amount of light falling on your subject. Both types are set up to give you an exposure reading for middle (or 18 percent) gray.

Light Direction

Light from the front (that is, photographing with the sun behind you) was probably your initial lighting of choice when you began taking pictures. It's easy to use, and it gives you accurate, sure photos. Front lighting is the type of lighting preferred by people-portrait photographers because it minimizes variations in, and blemishes of, the skin (it flattens them). That effect is the exact opposite of what you want when you're photographing a canine. You want to emphasize variations in the dog's coat—clearly recording on film or disk each individual hair—defining that smooth, longhaired, or wirehaired coat. You also want to capture the shape of the animal, and even its musculature, if possible. Remember, when you're outdoors, you can move your subject, or your own position, to change the direction from which the light is hitting the subject. If you're photographing indoors, you can simply change the position of the lights.

Backlighting (the sun is behind the subject) creates either a silhouette or an intriguing glow around the edges of your subject, depending upon your exposure and your use of secondary lighting. This is also called rim lighting

Our Pomeranian model, Honey Bear, is backlit in this photo. We used a reflector to bounce some light back into his face and chest. Note how the background is totally out-of-focus in this photo. I was quite tight on Honey Bear, with the camera set at 1/90 at f/9.5 using 100-speed slide film.

because it lights the edges, or rim, of the subject. Shadows are thrown forward when you use backlighting—that is, thrown toward the camera, adding visual depth. Beware of lens flare when you photograph backlit subjects. Place yourself where the sun can't shine directly into your lens. You'll get only a silhouette of your backlit subject unless you open up your lens one or two f-stops, or add secondary lighting with your flash. With this type of lighting, you can't rely on your light meter alone for settings.

"How do you capture the texture of a dog's coat?" is a question I'm asked often. The answer is relatively simple. I use lighting that emphasizes that texture. It's called cross lighting by painters and photographers, and it also adds roundness or form to the subject. Put simply, the main source of light on your subject, which could be the sun, a studio strobe, or a remote flash unit, should come from the side—that is, lighting across the subject. That's what emphasizes the texture of a dog's fur.

Use this diagram as a model for your own cross lighting setup.

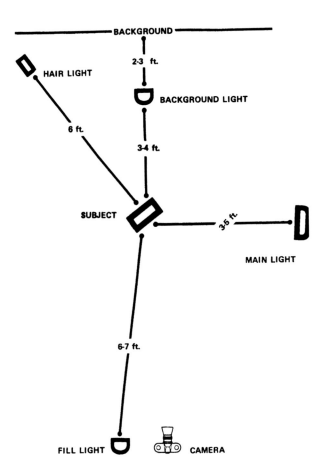

Tips on Using Cross Lighting

Simply using one light source from the side—whether that's the sun or some type of flash unit—will generally not give you all the detail you want to capture in a dog's coat. Again, there's no need to get into the chemistry of it, but film can only record details within certain limits. Here, we're talking about the differences between highlights (areas receiving direct light from your main or key light source) and shadows.

On page 66 is a diagram of cross lighting for a formal portrait of a canine. The main light could be the sun, a studio strobe, or a remote flash unit. The fill light, next to the camera, can be a diffused studio strobe or a flash unit, but it should be off the camera, or on a bracket, to prevent it from being

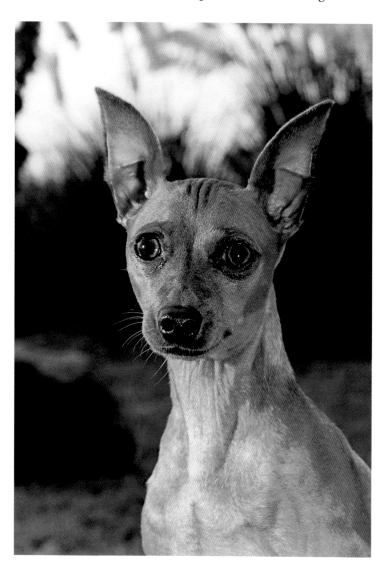

Cross lighting—that's with the main light source on the side—this time coming from the viewer's left, will give you maximum body shape and texture in a dog's coat, as in this photo of a Miniature Pinscher.

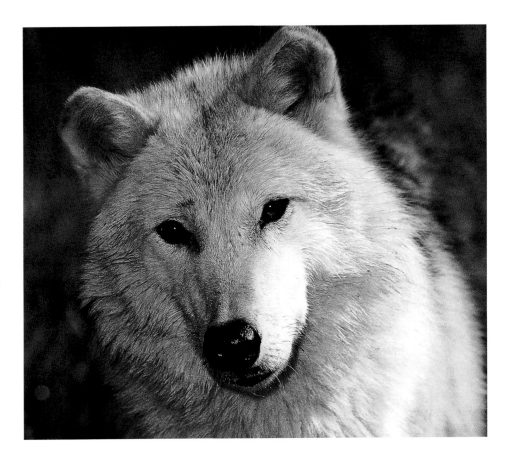

Again, cross lighting maximizes the texture of this gray wolf's fur. The sun was strong, to the right. I used flash fill to create catch lights in the wolf's eyes and to put some detail into the shadow portions of its face and chest.

directly above the lens on a hot shoe. The background light and the hair light are optional. They can be additional studio strobes or remote flash units that are set to trigger on a slave unit, which syncs with your camera and fires the light in response to a wireless signal. I like to have some sort of translucent diffusion on my fill light to soften it, and I strongly recommend using a hair light. You'll love what it adds to your photos. The distances from your lights to the subject will vary, depending upon the output of each light, and possible physical restraints of your location. Eliminate any shadows on the background that might be cast there by your fill light. To accomplish this, either move the subject farther away from the backdrop or light the background.

I prefer a one-stop difference between the main light source, sun or flash, lighting the subject from the side, and a fill-light source, flash or reflector, which is positioned near the camera and is aimed directly at the subject. The secondary light source produces a catch light in the eyes and softens harsh shadows. It actually allows you to see details in shadow areas that are invisible without its use. I usually set the fill light at about the eye level of my subject, and I like to diffuse it, which spreads the light evenly across my

subject. The main light is set higher than the subject in order to throw its light downward, as the sun would light the dog naturally.

Technically, this is a 3:1 lighting ratio. It's really not too complicated, once you've tried it. The important thing to know is that this ratio is well within the recording capabilities of your film. Here are three ways you can achieve that 3:1 lighting ratio:

1. Take two readings with a handheld meter. Use a flash meter if you're using a flash as one or more of your light sources. Or, you can use an in-camera meter. Be sure to "read" an area that receives light directly from the main light source, and a shadow area that receives no direct light only from the main source. The two readings should be no more than one f-stop different. You'll probably have to get in close to your subject to make these readings, unless you're using a spotmeter, or have your in-camera meter set to make spot readings.

2. Move your light sources to appropriate distances from your subject to achieve a one f-stop variation between the flash you're using as your main light on the side, and the flash that's your secondary or fill light near the camera.

3. Many of today's automated cameras allow you to set your camera's flash output to minus one. This −1 setting causes the camera's flash

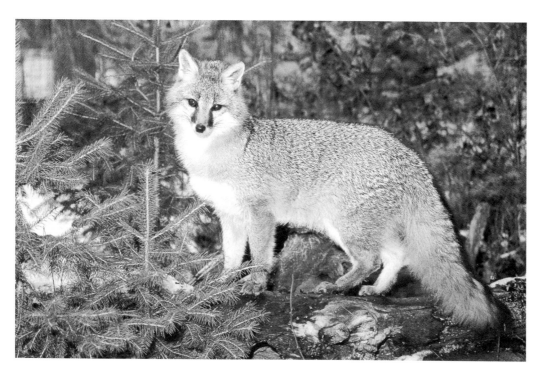

While there's very little need to use flash fill on gray winter days with low-contrast lighting, I did use my off-camera flash to add catch lights to the eyes of this tree-climbing gray fox.

system to produce one f-stop less light than the built-in meter's reading for the overall subject. Sounds complex, but it's really simple. The camera does all the work of providing you with correct flash fill.

Cross lighting isn't the only type of lighting to use when creating photographs of canines, but I've found it to be the best lighting to use to capture texture in fur. Still, there's no need to limit yourself to just one type of lighting. Create.

Winter: Nature's Cross Lighting

During the winter in the United States and Canada, Mother Nature provides cross lighting naturally. The sun's arc is low and to the south, producing low-contrast and interesting directional light almost all day long. Be sure to take advantage of it. Nature gives wildlife photographers an additional bit of assistance during the winter, too, since wild animals seem to be a little easier to approach because the animals aren't moving as frenetically. Animals also have thicker, more glorious, fur coats during the winter—and sometimes unique

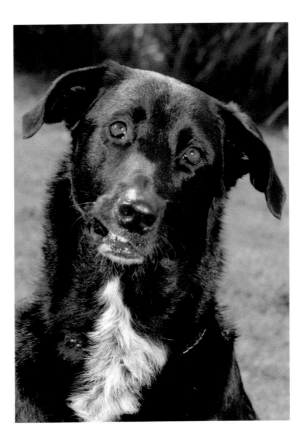

The hair light on this crossbred Labrador Retriever's head adds a lot to the photo, but beware of curled lips, like this. It's easy to miss a lip that's caught this way when you're looking through the viewfinder, and it ruins an otherwise lovely photograph.

This bracket I devised gets my flash off the camera, helping avoid that dreaded red-eye look. By the way, I use a quick-release mount for my camera on the tripod, so I can react quickly to a change in pose that I want to capture, like a subject suddenly lying down and looking "oh so cute."

seasonal color patterns, too. Snowy faces and visible breath can add impact to your winter animal photos.

By the way, you're less likely to need reflectors or flash fill when you photograph animals in snowy terrain. Snow and ice will reduce contrast for you, reflecting light into shadow areas, without your having to rely on artificial methods to do this.

Add a "Hair Light"

Portrait photographers use hair lights for people all the time. If you want to use a hair light, as I strongly suggest you do, you don't need to invest in studio strobes, though they're great to have. Many of the photographs on these pages were made using a simple accessory flash unit as a hair light. I mounted it on a light stand, triggered it with a slave unit, and pointed it down at the back of each subject's head, angling it in from the side so the stand didn't show in the background of my photographs. Since it was a small flash unit, I added a rolled-up cardboard "snoot" lined with aluminum foil to throw the light a greater distance. It works. Yes, you can be creative with equipment, too.

Avoid Getting "Red-Eye"

Here's a word of caution: when you use your camera's built-in flash unit, or a flash mounted on a hot shoe on the camera, you'll often capture subjects with

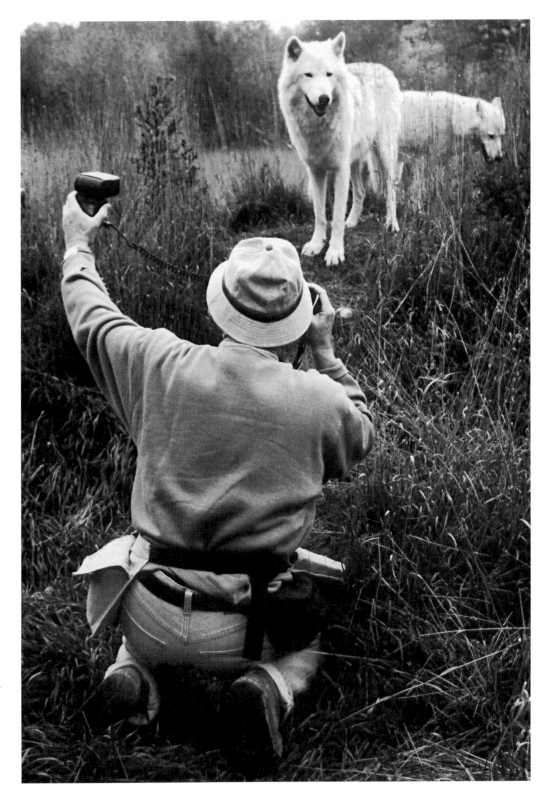

If you're using an auto-focus camera, it's easy to hold the flash unit in your hand, up and away from the camera, to prevent getting red-eye in your subjects' eyes, as I'm doing while photographing these captive Arctic wolves.

a problem called red-eye (when you're using color film). In black-and-white film, the same problem causes the eyes to glow white. This problem is caused by light reflecting from the retinas of the eyes. It's frequent in the photography of canines. I once photographed a red fox in Canada whose photo showed one red eye and one green eye. Sort of "the fox from hell" look. The solution to the red-eye (or green-eye) problem is to get the flash off the camera. I've rigged up my own bracket to solve this problem (see page 71). Similar flash brackets are available in camera stores.

You can also just hold the flash unit in your hand or mount a flash on a light stand, if you wish. Using a PC extension cord allows you to put the flash pretty much anywhere you want.

Getting the flash unit off the camera changes the angle at which the light hits the subject's eyes and prevents the reflections from bouncing back directly into your lens. Accessory cords are available to connect your off-camera flash to the hot shoe on your camera, allowing you to continue to use the camera's built-in systems. So-called automatic red-eye reduction, which is available on some cameras, seldom works effectively for dogs, though it might help somewhat. Try turning up the room lights (if you're photographing indoors), switching to a shorter-focal-length lens, or setting your zoom lens to a shorter focal length. Telephoto lenses make the red-eye effect more pronounced. If all else fails, try a red-eye pen. They work. Software programs are also available to remove red-eye digitally, while retaining the original eye color of your subject.

Other Flash Tips

We talked about shutter speeds in the previous chapter. One thing you need to note from the instruction materials provided by the manufacturer of your camera is the shutter speed at which your camera synchronizes with the flash. Most cameras synchronize the firing of the flash unit between 1/60 and 1/200 of a second. The flash won't fire when the shutter is open if you've set the x-sync incorrectly. You won't get what you're expecting to see in your photographs if your camera syncs at 1/60 of a second when you've got your shutter set at 1/125. Some camera manufacturers make "high-speed" accessory flash units. Mine can synchronize up to 1/8,000 of a second, for instance. I use a separate battery pack to power my flash unit, which gives me an increased number of flashes per charge, as well as a quicker recycle time for it to get ready for the next shot.

If you're using an older, "dedicated" flash, set the ISO on your flash at double the ISO of the film you're actually using in your camera. For example, if you're shooting 400-speed film, set the flash (not the camera) for 800-speed film. The camera should remain set at the correct 400-speed. This will

automatically give you one f-stop less light from your flash than your automated camera is giving the film, maintaining that 3:1 ratio we've been talking about.

It's important to realize that shutter speed has no effect on flash exposure, except for the maximum sync speed. The flash lights for only a fraction of the time that the shutter is open. Control of flash exposures is established through your f-stop settings.

Finally, when you're photographing young pups, be aware that any light directed into their eyes must be carefully monitored. Light that's too strong can cause permanent eye damage to very young puppies. Ask a veterinarian for advice before you photograph puppies using flash fill.

Here's our little Pomeranian buddy, Honey Bear, again. This portrait of him was made at 1/125 of a second at f/8 with the on-camera flash set at –1 f-stop using ISO 100-speed slide film.

Here's another look at Honey Bear. This photo was made using an f-stop of 11 with the off-camera flash set at −2 stops. Notice the increase in the sharpness of the bushes in the background of this second photo resulting from only a one f-stop change in camera setting. Analyze what other changes you see from any changes I described.

Spotmetering

Many wildlife photographers use only spotmetering to measure light, aiming at an area that is neutral gray and that is in the same lighting that their subjects will be in or close to where they think the subject will appear. This is often easier than trying to read the light on the animal itself. It's a great technique for wildlife photography. Neutral gray is often referred to as 18 percent gray because it reflects 18 percent of the light that falls on it. All light meters give readings for a middle gray tone. It doesn't make any difference at what you're pointing the meter, whether it's white or black; the meter will adjust

Honey Bear once again demonstrates for us. This time, his sit-up was stopped at 1/200 at f/19 on ISO 200-speed slide film. The off-camera flash was set at −1 f-stop.

to read it as gray. Therefore, when you're using a meter, you must select—or create—the shade that represents the middle tone of your image.

Another way to spotmeter is to read a highlight area and a shadow area on your subject. Your film should be able to capture what you see if there's no more than one f-stop, or a stop-and-a-half, difference in the two readings. When you're using print film, expose for the shadows. Print for the highlights. Talk to your lab about this if you don't do your own darkroom work.

Control Your Aperture

Simply put, an aperture is an opening. In many cameras, the size of the opening in the lens can be varied to change the amount of light allowed into the camera. This also changes the depth of field, which is the front-to-back sharpness of your photo. When the aperture is wide open, the maximum amount of light can pass through the lens to the film. This, however, minimizes depth

Not much depth of field is required to capture a Pug's nose, eyes, and ears all in focus.

Brittany Spaniels, and most other breeds, have greater distances from nose to ears than do Pugs. Therefore, they require that you increase your depth of field for optimum sharpness.

of field. The maximum aperture of a lens is often referred to as the "speed" of the lens. Therefore, the larger the aperture a lens can achieve, the "faster" the lens is considered to be. The sizes of those openings are called f-stops.

F-stops are referred to by numbers, which are actually fractions, though they're expressed without the appearance of being a fraction. If your camera's aperture is set at f/11 (for now, think of it as "f-1/11"), changing it to f/8 (again, think of it as "f-1/8") will allow twice as much light to strike the film in the camera. Yes, 1/8 is greater than 1/11. Conversely, if you change your setting from f/11 to f/16, you'll be letting in half as much light (1/16 is less than 1/11). F-stops are calculated by dividing the focal length of a lens by the diameter of

the aperture, just in case you needed to know. Actually, you only need to know how to make them work for you. Note, f-stops are in steps of double or half, depending on which direction you're changing the settings. That coordinates nicely with shutter speeds, which also change in the same manner. The change from 1/60 to 1/125 of a second is twice as fast (well, nearly so), but allows half as much light to enter the camera; 1/60 to 1/30 is half the speed, but that change allows twice as much light to enter the camera. Yes, both shutter speed and aperture control the amount of light entering the camera.

The Allan Fur Factor: To capture detail in a black dog's coat, open up your aperture one f-stop, as I did for this Black Labrador Retriever's portrait. Notice that the sun is behind and to the right of the subject. Off-camera flash was also used to record maximum detail in the fur in shadow areas, while still retaining those shadows. While I generally suggest that collars be removed before I make a photograph of a dog, this handsome red collar adds a nice touch of color to the photo.

The Shortcomings of 1/125 or Faster

We've established that canine portrait photography requires a shutter speed of at least 1/125 of a second to arrest most movement. That limits the apertures available to us, since we still must correctly expose our film. And that's why I recommended 400-speed film, so we won't be limited to wide-open, or nearly wide-open, apertures. Remember, aperture also controls depth of field—that is, the portion of the photograph which appears sharp, in focus. The smaller the aperture you use (such as f/11, f/16 or f/22), the greater depth of field you'll get. If you use f/8, f/5.6 or f/4, you get progressively shallower depth of field. There's a depth of field preview button on many camera models. This button closes the lens to the aperture at which you've set the camera. Otherwise, you're seeing through a wide-open lens when you look through the viewfinder of a single-lens reflex camera, and that shows you a brighter image, but with minimal depth of field. The image in your viewfinder will darken when you push the depth of field preview button, but it allows you to preview what will actually be in focus in your photograph.

As I mentioned, portraits of canines require greater depth of field than do portraits of people. This is because there's more distance between the tip of a dog's nose and the tips of its ears than is true for people. Obviously, there's a big difference in breeds. There's an extreme difference in the nose-to-ear-tip distance between a Pug and a Brittany Spaniel, for example.

But the need is there. Focus precisely on the dog's eyes for portraits. When using a short telephoto lens, I suggest you try to maintain an f-stop between f/11 and f/22. This is especially important for head-and-chest portraits. While f/8 will be acceptable some of the time, use it and larger f-stops (remember, that means smaller numbers, like f/5.6 and f/4) with caution. The focal length of the lens you're using also is a factor that helps determine depth of field, as is the distance from your camera to your subject. The closer you get to your subject, the less depth of field you'll have at any given f-stop. You'll have to work out your specific combination yourself. Test the combinations of various shutter speeds, apertures, and lenses. Bracket exposures. And test variations in lighting. Make notes, so you know exactly what settings you used for which lens for every test shot you make. That's the only way you can be certain how you got that shot which turned out so well—and know how to reproduce those successful results again and again.

If your camera doesn't stop down enough in a specific situation to allow you to shoot at its sync-speed of, say, 1/125 at f/22, for example, consider using a neutral-density filter, which gives you the opportunity to shoot at a workable f/16. Or use high-speed sync capability, if your camera and flash have this option.

Tips on Photographing Black Subjects

"How do I get a good exposure of my black dog?" A point-and-shoot camera won't help you conquer this problem. The solution to this question, applying The Allan Fur Factor, requires a camera with adjustable apertures.

To avoid getting a black "blob" when you try to photograph a black dog (see example on page 79), open up your camera an extra stop (from f/11 to f/8, for example) or half-stop (f/11 to f/9.5) from the metered exposure when you're shooting photos of "Blackie." Try both settings to determine just which is best for your specific subject. The reason for this adjustment in aperture is that black furry subjects do not reflect enough light to allow us to record maximum shadow detail on film when we use normal or average settings.

And Tips on White Subjects

For a white animal, the reverse is true. Close down a stop (from f/11 to f/16, for instance) or a half-stop (f/13 in this example). White reflects all light waves, and photos of white dogs tend to be overexposed as a result.

Some photographers choose to bracket their exposures to capture white whites. They advocate spotmetering or taking a close-up lightmeter reading of a neutral gray object, then bracketing in half-stops until they have at least five exposures. My recommendation is to use The Allan Fur Factor as your starting point. Then, if you want to be super careful, bracket a half-stop over and a half-stop under your starting exposure. You'll soon reduce the amount of bracketing you do after you see the results.

This will help you get around the fact that exposure meters try to make everything 18 percent gray (that's the way the meters are calibrated). Gray is not what you want when you're photographing a black or a white dog!

Proof Positive

Back in May 1995, an article June and I did for *Popular Photography* magazine created something of a brouhaha about exposures. One confused reader wrote the magazine that the photographers he'd studied under at seminars advised him to do just the opposite of what we'd advised. Another reader called ouradvice "heresy, twice over." My response is simply that my years of successfully photographing fur, no matter what color it might be, have taught me this lesson. And I've done my homework—just what I recommended earlier that you do—test shots with careful note taking to record the details of each shot. Theory be damned; it's the results that count.

The magazine editors decided to do their own test, and they reported the results in the September 1995 issue. Their conclusion? "For detail in the fur,

The Allan Fur Factor: To get maximum detail in the fur when photographing a white dog, close down a half f-stop or a full f-stop, as I did when photographing this white mixed-breed dog. Notice that this technique works for all shades of white: the lamp, the curtains, and the dog. Tip: to get a white background to appear white in your photograph, it must be lit. I used two studio flash units just on the curtains behind the subject to keep them from looking gray in the finished photo.

follow the Allans, not the book." Follow my suggestions, and you'll get black dogs that are black, and white dogs that are white, with added detail in the fur. "Score two for the Allans," the magazine's editors added. By the way, the editors used black teddy bears and white teddy bears as models. That's a good idea. Or maybe a tan or brown stuffed dog? These toys will be very patient as you work your way through the practice sessions I've suggested. And you won't have to worry about how to get your canine subject to sit still, nor how to attract its attention for these test shots, either.

SECTION 3

And Finally

All the tech stuff we've discussed in section II might be a bit bewildering to you right now. But these techniques should become second nature to you as you learn how to use your camera. Take out the instructions that came with your camera and reread them. Practice the use of each feature. You want the mechanical functions of making pictures to be familiar—something you don't even need to think about. This is important, whether your camera is a simple point-and-shoot, a fully adjustable, highly sophisticated 35mm single-lens reflex, or a top-of-the-line digital model capable of professional level output. 🐾

Obedience School Isn't Essential: Learning to Control Your Subjects

There's a little bit of philosophy involved in understanding how to control your animal subjects. So, philosophically speaking, learn first to accept (photograph) whatever your subjects are willing to give you. After you've captured those images on film or disk, work to improve what you've been getting. This is a lesson that thousands of photo sessions with animals—both domesticated and wild—have firmly imprinted on my mind.

BELOW: Oh, no! This image clearly illustrates a mediocre beginning to our photo session with this mixed-breed dog. But I began snapping the shutter before I tried to move her and improve her pose. She looks comical, at best. RIGHT: This photo was produced a little later in our session with that same mixed-breed dog. She's now directed and interested, which clearly shows in her bright expression. I think she looks charming here. And so did her companion person.

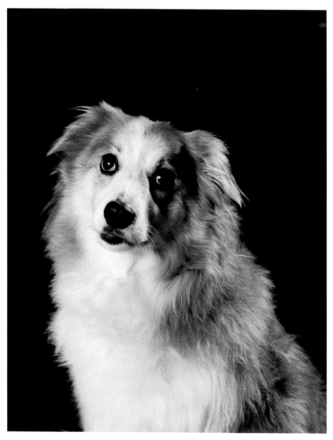

This wasn't the pose I wanted from an elegant Afghan Hound, but it's what he chose to do when he was first placed on my posing table. And I wasn't given the opportunity to get anything else. This is one of only two images I was able to make of this young Afghan. And it turned out to be an award winner—as well as a book cover.

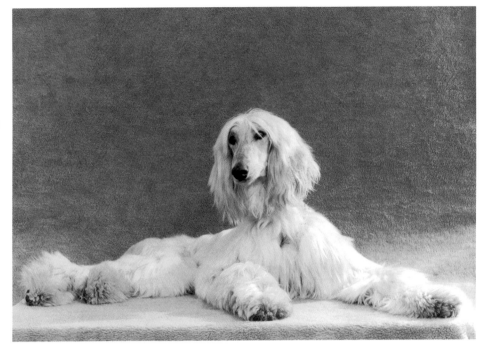

Though it wasn't behavior-caused, one incident permanently imbedded this bit of philosophy in my mind. I was photographing a young Afghan Hound outdoors. He was placed on my posing table, and he kind of stretched out, almost lounging like a teenager. He was comfortable, but his "pose" was too casual to be what I wanted to capture from such an elegant breed.

However, I managed to click the shutter twice as a shaft of sunlight broke through the heavy, dark clouds above. They were the last images I captured that day. The clouds suddenly opened up and rain poured down for the rest of the afternoon. The resulting award-winning photo pleased the dog's "person" immensely. And it pleased me, too.

"But He Isn't Trained . . ."

So many times, I've had people tell me, "I'd love to bring my dog to you for a photo, but she isn't trained for that." Most dogs aren't. But I am trained and experienced, and I've been successfully photographing "untrained" canines for more than a quarter century. Have I ever failed? Twice. And both times it was because we couldn't bring the dog out of a totally unflattering submissive countenance and posture. Of course, there's no question of training a wild wolf, fox, or coyote. While I've found it is a real pleasure to photograph an animal who has had obedience training—or is a trained animal actor—a trained subject isn't necessary in order to get top-notch photographs. First, you work

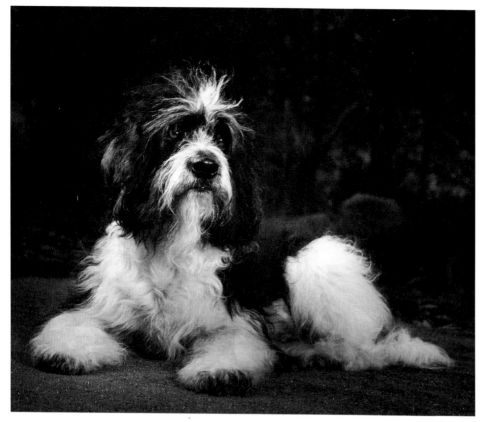

For those first photos in a session, capture whatever the canine subject is willing to give you, like this mixed-breed in the park. We added our own bit of AstroTurf for him to lie on in order to get a cleaner-looking location.

with whatever the subject will give you. Then you try to improve on what you're getting from that particular canine. And this is true for photography of wild canines in nature, too. Photograph what they'll give you (or allow), then try to improve what you're getting.

Okay. Let's assume you've snapped off a few shots of your subject. You probably took full-body shots of the dog doing whatever it wanted. Hopefully, the "pose" the dog put himself in was cute or appealing. The subject may, or may not, have been looking toward the camera. But you've got the images on film, or disk.

Now, try moving the dog so he's sitting down, with his body at a forty-five-degree angle to your camera.

As I mentioned in chapter 8, a small bite of something tasty (such as liver or a liver-flavored snack, or bits of hot dog) might get him to settle into that pose as you push down on his rump and push up under his chin or chest. Dogs are motivated strongly by hunger. Even though an animal is not obedience-trained, try holding the palm of your hand directly in front of his face, while saying, "Stay," in a stern voice. You'll be surprised at how often this works for all dogs—untrained, as well as those who are trained.

Wiggling and puppies just naturally go together. This mixed-breed pup is no exception. His wriggling efforts to escape were restricted, somewhat, by the basket into which we placed him. And I did end up with more than one usable photo from this particular session.

This eight-week-old Lhasa Apso pup was nicely restricted by a basket, making the puppy easy to light and to photograph.

If you're working with a very young dog or puppy, you might need to restrict the animal's movements. The posing table will help. Putting the subject into a basket or other container, as I mentioned earlier, will provide maximum restraint of the dog's movements. Be sure to choose photogenic items for props. Also be sure your subject doesn't disappear down into the basket (unless that's the shot you're trying to create). A towel, small pillow, or other soft, comfy object can be placed in the bottom of the "container" to raise the dog up to a desirable position for photographing. Make the containing object as elaborate or simple as you want it to be. It's your call; just don't "settle" for something. After all, the container will be part of your finished photograph, and so might the towel or pillow you used to establish the subject's positioning within the basket.

I was challenged to photograph a half-dog/half-wolf, who was being kept in a horse stall while its human companion agonized over the decision of whether or not to have the animal euthanized because it had threatened or attacked people on several occasions. There was no question about my

Sometimes adult animals need physical restraint for photography, too. He looks like a pleasant enough fellow in my photograph, but like so many other species crosses, this half-dog/half-wolf, was not trustworthy around people. Generally, half-dogs resulting from breeding between dogs and wolves, or coyotes, don't make good companions. There are, of course, exceptions.

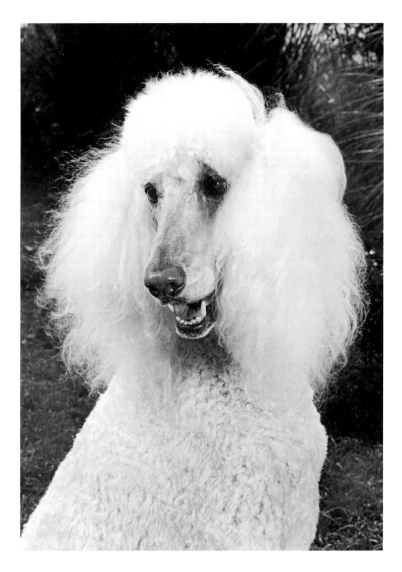

A helper is necessary to get a canine subject to look to the left and to the right of the camera. This Standard Poodle is looking at its companion person, who simply stepped to my left, and the dog's eyes followed.

moving it around, posing it. I wasn't even allowed to go into the stall where he was being kept. Bales of hay were placed in front of the animal, across the doorway; other bales were already stored in the stall, and they provided a backdrop for our photo. Light was coming through a window behind the subject. I added flash from a unit beside my camera to get a photo of a very handsome, but perplexing, subject.

Direct the Subject's Attention

Next, you want to direct the dog's attention. I like to try to get separate photos of my subject looking in three directions—a direct look into the camera, a look

to my left, and a look to my right. To capture a look into the camera, make a small noise when you're set to snap the shutter. Try a whistle, or a puppy whine, or even say the dog's name. Warning: Never, never, call the dog, "Here, Dusty." You don't want to lure your subject up out of the pose you've worked so hard to get him into. You'll probably need a helper to get your subject to look to the left and look to the right of the camera. Use soft noises, or a clap of the hands, or the whirling of a child's pinwheel. Just remember that you're trying to get the subject to look in different directions by turning his head. You don't want his body to move from that forty-five-degree angle you established. Once the dog has learned that a given noise really signifies nothing in particular, you'll have to switch to a new sound in order to get his attention again. I've found two or three times for the same noise is about all that will work.

On one occasion, I was photographing a pair of deaf dogs for a magazine spread. I was so used to getting my subjects to respond to sounds that I continued to use them, even though I'd been told the dogs were deaf. I tried motion (like the pinwheel), but they didn't always see that, either. Finally, I jumped up, and when I landed on the floor the dogs would look toward me. They must have felt the vibration of the floor on which they were sitting! I used a fairly long cable release, jumped up when I was ready to take their picture, and got my shots of attentive, directed dogs.

A pair of deaf Dachshunds proved to be a real challenge. I finally managed to get their attention by jumping up just before I snapped the shutter. Could they have been feeling the vibration of the floor when I landed? Nobody ever accused me of being "light on my feet." Maybe that can be a good thing.

ABOVE: This West Highland White Terrier cocked his head inquisitively when I blew into my slide whistle. It was exactly the reaction I wanted from this handsome little dog. RIGHT: Perhaps I got too much of a good thing from this young Boxer when I tried the slide whistle on him. The result is cute, even whimsical. The amount his head is twisted creates more of a humorous photo than a portrait, but sometimes it's fun to smile with your subjects.

You Control the Action

You need to pay attention to your subjects. Learn how to control them by watching them carefully during your "getting-acquainted" session in the beginning. If the dog's human companion brought a favorite toy, simply holding the toy where the dog can see it will give you a good, directed expression. Just don't let playtime begin with a comment like, "Where's your ball," which usually sends a dog into a frenzied hunt for the object. You might have to remind the dog, even if he is obedience-trained, "Stay!" before actually showing the toy to him.

And who wouldn't smile with this German Shorthaired Pointer? That little twist of the head is charming.

People often like to see a photo of their dog with its head cocked to one side. It's cute. My favorite way of inducing this response is to use a slide whistle. As the sound the whistle makes goes up in pitch, the dog's head twists more and more to one side, or sometimes, it goes back and forth from side to side. Puppy-like whimpering is good, too. Whatever you use, remember to try new sounds until you get the type of response you are after. Different subjects react differently to various sounds. And sometimes you can get too much of a head twist, turning the photograph into something comical. That's okay, if you want humor. No attention-getting device works every time. You just have to keep trying until something works the way you want it to, this time.

As the photographer, you are in charge. You must control your set. Do not allow a dog's companion person to take over getting their dog's attention. Only one person should be working to get the dog's attention. You designate who that is to be.

ON THE **WILD** SIDE

There's no question about wild canines being trained. And there's no question about moving them, posing them, or not. It just isn't going to happen, unless the animal decides to do it. However, with patience, you might find that a wild canine will move into a pose you like. You must be ready! Do not ever try to use food treats to move a coyote, fox, or wolf, or to capture its attention. That's for your own safety. I don't carry gum or any kind of snack in my pockets when I'm working in the wild. By the way, I choose never to go out alone, either.

BELOW: A coyote will often respond to a good human imitation of a howl, as this one did. RIGHT: Red foxes are very secretive animals. We seldom get a direct look at a fox in the wild, but I know they're often looking at us. Knowing this, I was delighted to capture this very cautious look from an inquisitive red fox peering from behind a fallen tree. The success of this shot results from the naturalness of the situation, and from my ability to respond to the actions of the reclusive wild canine subject.

A small and intriguing sound will get a wild canine's attention, if you want it to look toward you. A howl will often get a coyote or a wolf to respond with a howl of its own. Getting wonderful photographs of wild canines isn't so much a matter of your being in control and getting the animal to respond to you. It's your ability to respond to the subject that will determine your success in the field.

If a particular photographic situation gives you problems, frustrates you, or seems to be driving you crazy, think about how you can use your experience and the tips contained in this book to solve your problem. The ability to creatively solve problems will help you become a better photographer of canines. After all, isn't that why you're reading this book?

"Nothing in this world can take the place of persistence," former President Calvin Coolidge once stated. He continued, "Talent will not; nothing is more common than unsuccessful people with talent. Genius will not; unrewarded genius is almost a proverb. Education will not; the world is full of educated derelicts. Persistence and determination alone," he concluded, "are omnipotent." For animal photographers, I'd add patience to his admonition. Patience and persistence pay off.

Sit, Stay!: Posing Dogs (or Not Posing Them)

A pose is not something specific. It's actually just the position or placement of your subject when you make the photo. What that pose might be is up to you and your canine subject. It's important to know what's considered "correct" for the breed you're photographing. If you don't know what is "correct" for a particular breed, ask the owner. Sometimes, though, we think of a "pose" as something artificial. That appearance of artificiality is something we'd all like to avoid in our photographs, especially in our photos of canines.

Start with any pose that's comfortable for the dog. While this is a relatively good photo of a Basset Hound, the fact that it's sitting sideways to the camera creates an image that's, in my opinion, less than ideal.

Here's a Basset sitting in a much more pleasing, more photogenic, pose. I moved it to achieve this improvement in positioning. Notice its ears are "soft"—very important in this breed—and its eyes are looking upward, which emphasizes its famous "sad expression."

I liked this Shetland Sheepdog in a sideways pose because this position emphasizes the beautiful, full ruff of fur on the dog's chest. I added emphasis to the dog's chest with the lighting.

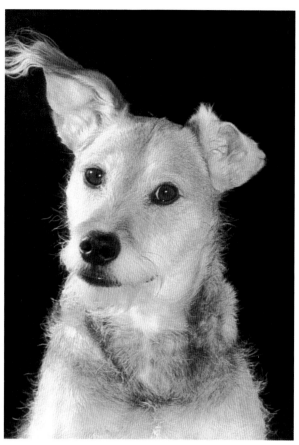

This mixed-breed dog's person often saw him with one ear up and one ear back, like this, so she loved this photograph of her canine buddy.

Start Wherever the Dog Wants to Start

As I mentioned earlier, start working with whatever the dog wants to give you. Let the canine choose its own pose. That could be sitting, standing, or lying down. Just work within the dog's comfort zone, in the beginning. I like to remove the dog's collar, if it's wearing one, but only if I'm working in a confined space, or if the owner/companion tells me the dog is completely trustworthy. I don't want to have to go find my subject who's run off somewhere.

Correct that Pose

If your subject puts itself into an impossible-looking pose, then you are obligated to create a comfortable new pose in order to produce the very best photograph you can create. Look for your subject's distinctive good points, whatever you and the dog's owner/companion agree is special or unique, and

ABOVE: This young Schnauzer's pose clearly states that it's not comfortable. This image could be salvaged by cropping those stiff front legs, creating a photo of only the young dog's head and chest. RIGHT: I photographed this old crossbred German Shepherd as he was. I wanted to record that wonderful expression he had for his loving people, who were standing nearby.

emphasize them in any way you can. Help it find a new and comfortable way to sit by moving its feet to a position directly under its chest, which will also tend to thrust out the chest more.

On occasion, a dog will be brought to you that cannot be posed, or moved much, because it's old, or perhaps in pain from arthritis or some other ailment. When an animal lacks mobility, you must simply work with what the dog can give you. I photographed a lovely old German Shepherd mix whose arthritis and other severe problems had brought the dog close to "its time." If the dog's health had allowed me to move him around a bit, I'd have brought his right forefoot into the picture (above), which probably would have moved his head to the viewer's left, leaving a little more room for the eyes to look within the photo. But we must remember to work with what the animal is able to give us. That's not always going to allow us to create what we might consider to be the ideal image. It's essential for you to remain aware of the impor-

tance a photographic session may have for the animal's people, who are trying to create something by which they can fondly remember their beloved pet.

Other times, no matter what you try, a dog will not be comfortable with the unusual situation of having its photograph made. This can be especially true of very young puppies. Try having the owner/companion or your helper pick up the pup, holding it securely with hands kept as far away from the pup's face as is safely possible. If you lower your perspective and move in tight, you can keep extraneous details out of the photograph, getting sky as a background, for instance. Clouds make a nice background, but you need to be shooting stopped down (a small aperture) to make sure the clouds look sharp in the resulting picture. If you're unable to eliminate the holder's body from the photograph, and capturing part of a person bothers you, drape your helper with a cloth (black or dark brown velvet finish seems to work best). I've used this technique often with cats, too, and my seated helper seems to "disappear" behind the cloth when I come in tight on the subject.

Move in tight to visually eliminate your helper's hands, and lower your camera to get sky in the background, as I did with this not-too-sure mixed-breed youngster.

An unlikely pose, but simply holding a puppy or small dog, like this Shar-Pei puppy, can allow you to move in close for an appealing photograph. Yes, there's still room to move in tighter.

A familiar blanket reassured a nervous Bichon Frise, and I was able to proceed with photographing it in its home. The dog is sitting on a kitchen counter—on its blanket—and I hung a black backdrop behind it to create this photograph.

Sitting, Try an Angle

Generally, I try to get some photographs of my subjects sitting at an angle of forty-five degrees to the camera lens, or at nearly that angle. I was once photographing a nervous, uncomfortable Bichon Frise in its home. It remained uncomfortable with what I was trying to do, no matter what I did to try to reassure it that it was safe and secure. I finally achieved my goal by giving the dog a blanket with which it was familiar. Sitting on the blanket seemed to reassure the Bichon, and the photo session moved on. It's a sweet-looking little dog, and it certainly deserved the consideration for its comfort that it got.

But take heed: when you photograph a sitting male, be aware of its genitalia. This is especially necessary with taller breeds. The longer the dog's front legs, the more likely you are to expose male genitalia when the dog is seated. It's best to keep those "private parts" private. Move your camera position to accomplish this, rather than trying to shift the dog a little bit. Or, zoom in closer for a head-and-chest-only portrait.

Since I don't use "glue" of any kind to keep my subjects in place, I'm not always able to photograph what I consider to be an ideal pose—but I try. You'll see examples of subjects sitting at a forty-five-degree angle throughout this book.

The positioning of an animal's front leg or legs, as in this photo of our mixed-breed model, Jake, can help hide the genitalia.

This standing Rottweiler exhibits all those attributes of strength and ruggedness for which the breed is known. The dog is posed at a forty-five-degree angle to the camera, and its head is turned a bit toward the lens. The dog's ears are cocked, erect, and the Rottweiler's mouth is closed, giving the animal an attentive, intelligent appearance.

Standing Strong and Solid

Some breeds just seem to look correct standing. To me, no breed exemplifies this thought better than the rugged, substantial Rottweiler. It's a strongly built breed known for its great courage. And its natural stance clearly indicates all these admirable attributes. In my opinion, other breeds that look good standing are sporting dogs, especially those with long, flowing coats; the Afghan and Borzoi Hounds; and some of the herding breeds. Any breed, or mixed-breed, can be successfully photographed in a standing pose. Arrange the dog's body at an angle to the lens (not flat, sideways across the lens, or straight on into the lens), with a three-quarters view of the face for best results.

The Stacked Pose

In the dog show world, standing is often referred to as being "stacked." I normally leave photos of stacked dogs (standing as they would be presented for judging) to the experts—the dog show, or ring, photographers. If someone

wants you to create a photograph of a stacked dog, have that person stack the dog for you. The positioning of the dog varies somewhat with the breed, so the handlers have to know what they are doing for that particular canine. It's okay for them to remain in the photograph with the dog, if they wish. They'd be placed behind the dog, away from the camera, but might have their hands on the dog. That's the way it's done at shows. Remember to set your exposure for the dog's fur, not for the overall "scene." The brightness of the sky can mislead your meter, so get in close to the dog to read your meter, or spotmeter it. Shoot the photograph of the dog (and handler) from the side—straight on. Yup, time to get down on your knees.

Katie, one of our Corgis, would stand in a stacked pose with almost no handling, but she was an experienced and outstanding show dog. She won many best of breed awards, as well as first place in the veteran's class (for champions over eight years old) at the breed's national specialty show. Though it isn't the usual thing in photos of stacked dogs, I had Katie turn a bit toward the camera for the photograph (below) to capture a three-quarters view of her face. June only had to quietly say her name to get Katie to turn and look at her, ears up, as a Corgi must be presented to judges.

Our tricolor Pembroke Welsh Corgi, Champion Kiss-Me-Kate of Jalma (we called her Katie), in a stacked pose.

I lowered my camera when this Lhasa Apso lay down. Because of the abundance of hair over its eyes, I lowered my camera even more, so I could still look into the eyes through my lens.

Lying Down Can Work

Lying down is another pose that canines often give us naturally. When your subject lies down, you'll have to lower your camera, in order to stay level with its eyes. You can capture your subject with its body either at the desirable forty-five-degree angle we've talked about, or straight on. You can also choose to come in close, or zoom in, to photograph just the dog's face. By the way, look carefully at that face before you snap the shutter. All too often, I've seen a lip tucked into the mouth in a most unappealing way (see page 70). Correct it first.

Environmental Portraits

Portrait photographers of humans have been making environmental portraits of their subjects for years. These are portraits created in a setting that adds to, or enhances, the final portrait. Usually it tells something additional about the subject of the photograph. And this approach can be used for canines, too.

I've done environmental portraits of dogs in their favorite places, like a bed they nap on, a footstool where they sit with their companion human, or a park where they're often taken for a walk. I've also photographed dogs on a sun deck, on a hearth, and in their own yard. This idea can be expanded to include a Border Collie herding; a Pointer in the field; a Bloodhound with its

There's no question about this Golden Retriever being a Guiding Eyes for the Blind dog when you look at this environmental portrait. And doesn't the dog look proud to be doing this wonderful work? It was a cloudy day when I made this photo on the Guiding Eyes for the Blind campus. I added off-camera flash fill set at –1 f-stop. The low-angle perspective adds much-deserved importance to the subject.

nose to the ground; or a Siberian Husky in the traces of a sled, doing whatever is considered the dog's function, or "work."

An environmental portrait is not a snapshot. It is, essentially, a portrait of the dog. The secondary interest in the final photograph illustrates something about the individual dog's life, or something about the breed. The dog must be put in portrait lighting. And be sure you get close enough to your canine subject so that it doesn't get lost in all that setting. If there's a trick to this type of photography, it's to establish a proper balance between the canine subject and the secondary subject. To keep it simple, I suggest you try to get at least one f-stop less light on the secondary subject (or background) than you have on the main subject, the dog. This will add emphasis to your canine subject.

If you're combining flash fill with sunlight, meter the flash output on the dog as if the flash were the only light source you're using. Let's say it reads

Reflecting each other's pose, and touching, this pair of Pembroke Welsh Corgis poses prettily for the camera.

f/11. To achieve a 3:1 lighting ratio using the sun as your main light, meter the sunlight on the dog to find out what shutter speed you need to use to get a reading of f/16. This establishes both your f-stop and your shutter speed.

Posing Groups

Whenever you're photographing more than one subject, try to get them touching or interacting with one another in some way. If you do use honey, chicken fat, or some other device to create interaction between your subjects, be careful not to let the device or material that initiates a sniff show in the final photograph. Use very small amounts of the "sniff initiator."

Want a real challenge? Try photographing three or more dogs together. Photographing a litter of eight Boston Terrier puppies nearly led to a divorce at our house. Well, almost. June and the pups' owner were working to keep the eight squirming little pups together, while I was "composing" from the camera. After a lengthy series of trials and tribulations, June dropped out of sight behind the posing table, urging me to snap the shutter. But I didn't take the picture. I said, "June, could you move that one on the left into the group a bit more?" To her credit, she moved the puppy, but I heard about it later!

In groups of two or more, try to get your subjects touching each other, or interacting in some way, as in this photo of eight, five-week-old Boston Terrier pups. Don't try this without a knowledgeable helper!

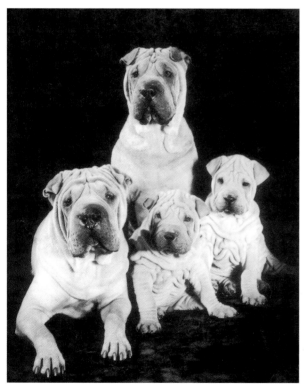

LEFT: Here's a different sort of family group—mom, dad, and the two pups. These Shar-Peis are grouped in a triangular shape, which is pleasing to look at. By the way, they're posing on a dining room table, draped by us, of course. Studio lighting was used to emphasize their wonderful wrinkly coats.

BELOW: This group of Basset Hounds represents four generations, moving from the oldest on the viewer's left to the youngest on the right. They're posed at an angle to the camera, and they're touching one another, to help keep it a unified family group.

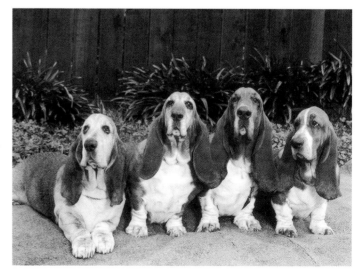

It was great fun trying to photograph a doggy birthday party, even though it was very difficult to keep the partying pooches out of the food.

Creating a Story

On one occasion, we were asked to photograph a dog's birthday party. It was to be attended by other canine pals of the birthday boy. The party became a television story for one of our local news channels, and the cause of much laughter and merriment. In fact, at one point, the television reporter couldn't talk because he was laughing so hard at the antics of one of the doggy guests. As you might guess, it was very difficult to keep the "guests" from gobbling up the food. They certainly weren't waiting to be invited to the table. The party

A subject that's at ease will give you better, more creative photographs, like this portrait of a very comfortable Beagle with its adoring gaze toward its off-camera human companion.

This mother-daughter pair of Lhasa Apsos was totally comfortable and relaxed for their backyard portrait. They're on our posing table, with an overhanging tree providing background.

guests brought presents, wore party hats, had napkins tied around their necks, and were served "cupcakes" (a dog food concoction of some sort). The setting was festive, made to look as much like a child's birthday party as possible. I'm not sure I gave the event the ultimate photographic coverage, but June and I certainly had a great time helping to create this story. It's fun trying new things, and the challenges can be rewarding, as long as you keep your sense of humor. Go ahead. Give it a try.

Don't Forget: Comfort, First and Foremost!

A comfortable dog will give you a much more pleasing photograph in the end. While it's good to try to improve what you're getting from your subject, be willing to accept whatever makes your subject feel safe and secure, and record that with your camera. That's the real test. You'll be more pleased with the photographs you create if your canine subject has been comfortable with you, has felt safe and secure, and has enjoyed itself.

With wild canines, like this coyote, there's no opportunity to pose or place your subject. And certainly, you'd never place a dog in this stance for a photo session, but it works here—because it's so natural. Of course, the subject chose where to stand. However, I gave my wild friend a direction to look by tossing a pebble to my left (I also could have used a snowball), out ahead of the coyote. He responded by looking interestedly to try to find the source of that small sound of the pebble landing, and I got my photo. By the way, dark backgrounds like this seem to work best for wild canines.

My 400mm lens didn't get me quite as close to the coyote as I wanted to be, so I went to the folks at my professional photo lab and asked them to make a reproduction-quality duplicate, cropping the original a bit on the top and right-hand side. This crop enlarged the coyote in the photograph you're looking at and bestowed added importance on the animal.

CHAPTER 12

Good Boy! Good Girl!: Specific Behaviors Can Help You

A dog's love of licking another, or the problem of too much tongue hanging out on a hot day, are two examples of natural canine behaviors that can make, or break, photographic excellence. Playtime and parental actions are additional patterns of behavior that can provide your photography of canines with more visual impact. I'm going to show you ways to make these behaviors work for you in creating better canine photographs.

Use a Little Fat or Honey

Would you like to make a photograph of a dog licking another dog, a kitten, or even just licking his chops? The simple solution is to give the subject something to lick. Place it exactly where you want the animal to lick, and put it there (or have your helper put it there) just before you snap the shutter. For instance, I've gotten wonderful photos of a dog licking a tortoise and a puppy licking a

This Pomeranian is Teddy, and he lived with a pair of desert tortoises and a couple of human companions. The humans wanted a photo of Teddy with one of the tortoises, and I wanted to create interaction between the two. The solution was to put a little chicken fat on the tortoise's shell. To get as good a look as possible at the tortoise and the action, I put the camera right on the ground. The medium-format camera allowed me to do this easily because the viewing screen is on the top.

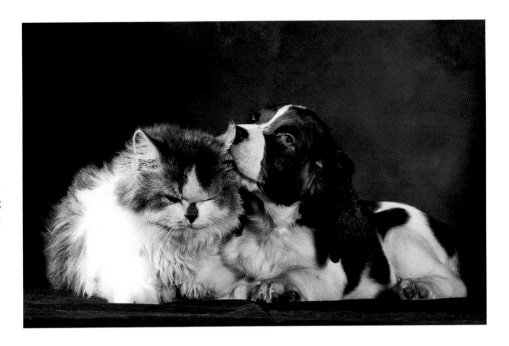

I also used the "give-'em-something-to-lick" technique on this Springer Spaniel puppy and Persian kitten. But this time I used honey at the base of the kitten's ear. Perhaps a puppy licking a kitten is less natural than a dog licking a tortoise. At least the kitten thinks so. Look at that feline expression! Can't you just hear the kitten saying, "Yuuuck!"?

kitten by rubbing a little chicken fat, bacon fat, or honey, on "the object of its affection." It works, as these examples clearly illustrate.

Tongue Control

But, sometimes, you'll want to stop a natural behavior in order to make a better photograph. Seldom does anyone want a photo of a dog with its tongue hanging out—especially if that tongue is really hanging way out. To solve this problem, you will need a helper who doesn't mind getting a hand wet in a dog's mouth. On a hot day, it's best to keep a premixed solution of water with a little lemon juice added in a small container. Then, when the tongue begins to hang out, simply have your helper dip a finger in the lemon juice solution and reach in to touch the dog's tongue. It works best if you do this "on the count of one-two-three." Then you'll know when to snap the shutter. Be sure to give the dog time to stop reacting to the strange new taste before you actually make that photograph. Try it a few times, and you'll get the hang of the timing.

A sharp noise, like clapping your hands, or a small noise that intrigues the subject, can also get your subject to pull in its tongue and close its mouth, momentarily, but the lemon-water always does the trick. Here's an additional thought about those hot, tongue-hanging-out days: Keep a bowl of water handy to refresh your subjects on hot days, but keep a towel handy, too, because not all the water gets into the dog's mouth.

A little lemon juice in water touched onto the subject's tongue will bring the tongue in every time, as it did with this American Water Spaniel.

Play Time Can Be Good

Dogs love to play. That's one of the things we love most about them. And they readily show how much fun they're having. The test of our photographic skills is to capture that fun on film or disk. First, we have to take control of the situation. That means, to a serious photographer, things must be set so we can make the photo we want when the action is happening. This includes background, lighting, perspective, film, and all the other variables we've already talked about. Then, we must anticipate when something we want to capture is about to happen. Frankly, if you wait until you see what you want, it's too late. You will have missed the height of the action. Anticipation is essential. And it takes practice to achieve the level of anticipation that leads to great photographs. But the more you can predict the behaviors of your canine subjects, the better able you'll be to predict where and when some action you'll want to capture will take place.

If focusing on a moving dog is a problem for you, you might try anticipating

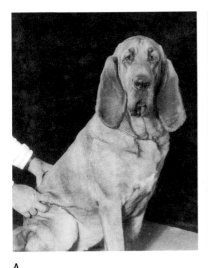

A

B

C

This Bloodhound posed reluctantly for our camera. His handler held him in place (A), while I zoomed in for a close-up (B) . . . of his tongue? No. A sharp barking sound caused him to draw in his tongue and look intently in the direction the noise came from, and we got our photo (C).

where the dog will go, and focus on that spot. The closer you are to your subject, the more critical focus becomes. You or your helper can entice your subject to the spot with a toy or with food if the dog doesn't go there on its own. Make curiosity work for you. Then photograph like mad.

Playtime can also involve the great outdoors. Adult dogs love to play with balls, too. Capturing this kind of play with your camera is more like photographing wild canines on the move. Set your camera on a tripod, use a telephoto lens, meter the fur of the dog in the light you expect it will be in, and set up the game. You might need two helpers to toss a ball, frisbee, or stick back and forth until the dog gets into the play. You'll probably need a shutter speed of 1/500 of a second for this type of action photo, and be ready to pan with your subject. To get the best meter reading on your dog's coat, zoom in until there's only fur showing in your viewfinder, manually set your f-stop from that meter reading, then zoom back out to compose the picture the way you want it. Or, you can use a spotmeter. Since you're in control, make sure you have the dog running in the direction your lighting favors—which probably will be toward the sun—so there are highlight areas on the dog's face. Also, remember to leave space in your composition for the dog to continue running.

This Boxer pup is on our posing table, and June was rolling the ball to it, taking it back, and rolling the ball toward the puppy again. I photographed the action while they were having fun. The puppy showed the pleasure it was having. On this roll of the ball, the pup put its foot on the ball to stop it, and I snapped the shutter. The result is a good look at a puppy at play.

To capture this Golden Retriever running through the water with a ball in its mouth, I set my camera with a 70–210mm telephoto lens (set on 210) on a tripod and panned the action at 1/250 of a second. I spotmetered off the dog in shutter-priority mode. Notice I left room in the composition for the dog to continue running on through the scene.

Nursing is Natural

There's no canine behavior more natural than a puppy nursing. But what might make a unique photograph is a puppy nursing from a bottle. A motherless mixed-breed pup at a shelter provided us with a model, and we set up the photograph to emphasize the puppy. It obliged us by pushing with its paw against the caretaker's hand, much as a pup would push against its mother when nursing naturally.

Good news! This pup grew up healthy and strong, and was adopted when it was eight weeks old. This is the same puppy I showed you sleeping with a rawhide bone in chapter 8, though it was older in that photograph, made shortly before its adoption.

ON THE WILD SIDE

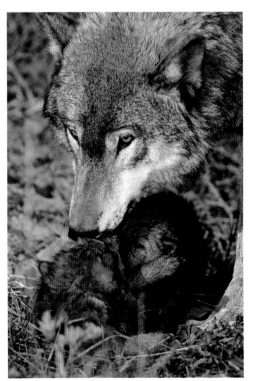

Gray wolves have the same natural behavior patterns as other canines, and these behaviors can produce wonderful photos, too. To make this type of photo, you must anticipate the action or activity. The only way to make sure you're ready to create photos of spontaneous action is to practice photographing them. You can even use an unloaded camera to get your eye and your finger used to working together so closely. And you can practice shooting (I hate to use that word when I'm talking about photographing—especially when I'm talking about wolves and other wild animals) without a camera as you go about your daily tasks. Just note what's happening about you, and pretend to push that shutter button. The action you practice on doesn't necessarily have to be canine, just sudden and quick. This practice will improve your timing. Preparation, and the ability to anticipate, are the keys to successful photography of canines.

Soon, you'll be able to capture a shot like a mama wolf doing what canine mothers everywhere do—sniffing her cubs (pups) to make sure everything is all right. This photo of motherly concern is tight, to emphasize the interaction between mother and cubs. I almost cropped her leg from her body, but I did manage to avoid this mistake, if only by a couple of hairs.

Top Ten Tips to Chew On: A Couple of Lists

Here are two lists of my top ten tips for creative canine photography; the first is applicable in a controlled environment, while the second can be taken with you into the wild. Whether you're an amateur or a professional photographer, or you're simply a person who wants to take better photographs of Fido (or Phideaux, if it's a breed of French origin), the following ideas will help you get better results.

I've presented a lot of information in these past twelve chapters, and I hope it's already proving to be of value to you. I'm going to give you a double bonus in section IV to help you improve your photography of canines even more. But first, let's quickly review some of the material we've already covered.

Chew on These Ten "Studio" Tips

1. *Be flexible.* Take what the animal will give you. Do the best you can with whatever happens naturally. You'll capture some great looks this way. Then make adjustments to improve what you're getting from your subject.

2. *Find a knowledgeable helper.* This person is vital to a successful photographic session with a canine. You might have to teach the subject's "person" what to do, or you might supply your own helper. You need to be allowed to concentrate on what's happening in front of the camera.

3. *Take charge of the set and the animal.* You must control both who is there and what is happening at all times. That might mean that you either allow, or ban, the subject's human companion from the set. Be aware of what effect the dog's person is having on your photography session.

4. *Stay behind the camera, and shoot using a telephoto lens, to prevent close-up eye-to-eye contact (threatening to a dog) with your subject.* This is especially important with an animal that's not your own.

5. *Relate to your subject.* Once you know about the dog's favorite toy or game, you can use that to help elicit the responses you want. A connection with your subject is imperative.

6. *Photograph at eye level.* Yes, photograph from the dog's perspective.

7. *Use a sturdy, solid posing surface or table.* You'll record engaging canines, not animals who look concerned or worried.

8. *Keep those attention-getting devices handy.* Whistles, pinwheels, balls, squeaky toys—they should all be within easy reach behind the camera with you or with your helper.

9. *Make it fun for your subject.* If it's "work" for you, it will be "work" (and probably unpleasant) for your canine subject, too. But your enjoyment and enthusiasm will be reflected in your subject's expressions. Be willing to do "anything" to get the photo. You'll be glad you did. Dignity be damned!

10. *Shoot lots of film.*

Of course, you need to have made all those technical adjustments and creative decisions that we've already talked about. And I hope you've remembered to review the checklist from chapter 6 as well.

Feast on These Wild Pointers

As a specialist in North American animals, I know you don't have to go on an African safari to get the opportunity to photograph wild animals. When you are photographing in the wild, work your way around your subject, so you get variations in the direction of the lighting and in subject location and background. Bracket your composition, your equipment, your ideas, in the same manner that many photographers bracket their exposures. It's important for you to understand that sometimes, only some of the time, the exposure that is technically correct might not be the absolute best exposure for a particular situation

or image. You will miss something, no matter how carefully you try to photograph a subject. That's okay. It's what you capture on film or disk that counts.

You can get natural-looking shots in many of today's zoos and wild animal parks, although I happen to choose not to utilize them. If you do photograph in a zoo, compose your photos carefully, eliminating any human references that might be there. Before you snap the shutter, look around the edges of your camera's viewfinder for telltale signs that you're photographing

in a confined area. You might need to ask zoo officials when the animals are most active, if you seem to be seeing only sleeping critters.

Here are ten additional tips to help you with your photography of wild canines.

1. *Telephoto lenses are absolutely necessary.* They give your subject added comfort room and provide for your safety. In many wildlife preserves, it's against the law to approach animals too closely.

2. *Habitat is an important part of wildlife photography.* Include it when you can.

3. *Take a friend.* I choose not to work in wilderness areas alone, for safety's sake. I recommend you do the same.

4. *Anticipate.* Wild canines are constantly on the move. Try to get ahead of them, so you'll be photographing into their faces, not toward their "other" ends. And watch the background. Keep it pertinent.

5. *Spotmeter the subject.* Or, take your light reading from an 18 percent neutral gray object in the same lighting you expect your subject will be in when you make the exposure. Remember to use The Allan Fur Factor to adjust your setting for very dark or white subjects.

6. *Photograph at the eye level of your subject.* And, when composing your photo, give the subject somewhere to look within your frame.

7. *Use a tripod, and photograph at an action-stopping shutter speed.*

8. *Apply the rule of thirds to avoid creating static photographs.*

9. *Do your photography early or late in the day, especially during "the golden hour."* Nap at noon!

10. *Carry only the equipment (cameras, lenses, tripod, film, filters, etc.) you'll need for the specific photos you're planning to capture.* Don't forget to carry extra batteries. If you're lucky enough to get the opportunity to photograph animals in their natural habitat, please remember to not be intrusive. Photograph without disturbing your subjects' normal routines. Naturally, you'll need a long telephoto lens to avoid confrontation with your subject. Move slowly whenever you're around animals. And, if you must speak to someone, keep your voice low and calm.

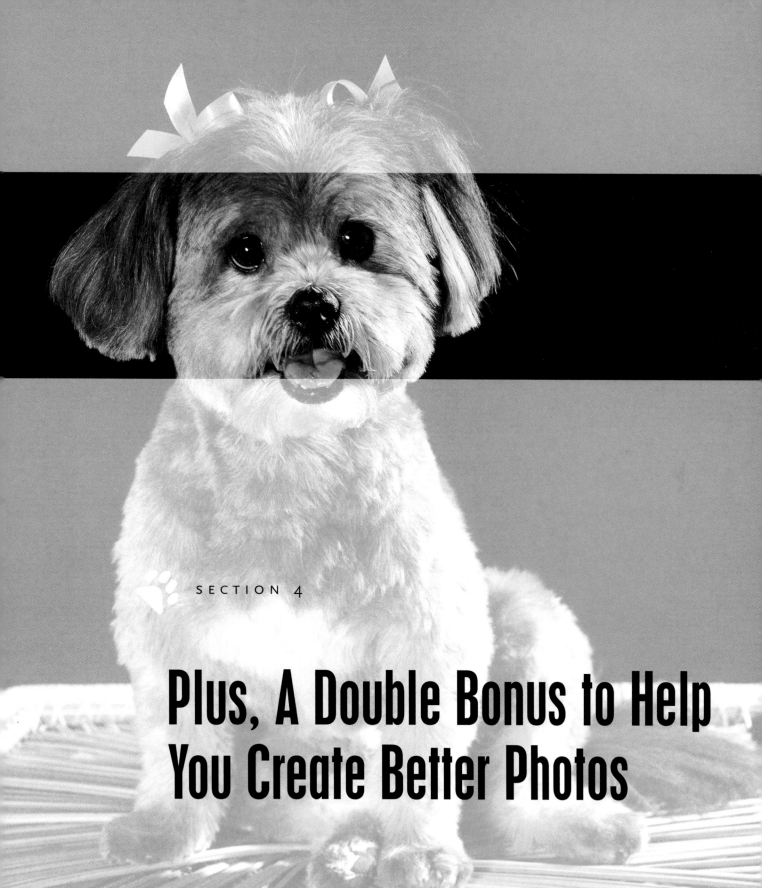

SECTION 4

Plus, A Double Bonus to Help You Create Better Photos

By now, you've got a good handle on how to improve your photography of all kinds of canines. Congratulations! Remember, the more you practice what we've discussed throughout this book, the easier (and more fluid) the whole process will become. Section III completed your instruction—and section IV is a bonus that gives you information to help you step up to yet another level of photographic excellence. 🐾

Look Through My Lens: Review a Photo Session

I'd like to share an actual photo session with you. From this sneak peak through my lens, hopefully you'll be able to see how the thoughts we've been sharing actually can be brought into play as you photograph a canine. Oh, yes, all these shots are full-frame proofs. You're seeing everything that I captured on film.

Let's Begin the "Shoot"

My mixed-breed subject in this shoot is actually a canine senior citizen. It's her clipped coat that gives her the puppy-like appearance. Because she's a small animal, I begin by putting my medium-format camera with a 127mm lens right on the ground for the first exposures. Actually, this places the camera a little below her eye level, a position that increases the dog's importance in the photos I'm about to capture. I've left the dog's collar on, since its color matches the bows her companion person has put on her specifically for this photographic session.

My camera is loaded with Fuji HG 400 negative film. I like the natural color this film gives my subjects. My shutter speed is 1/125 of a second. The f-stops I'm using range between f/11 and f/16.

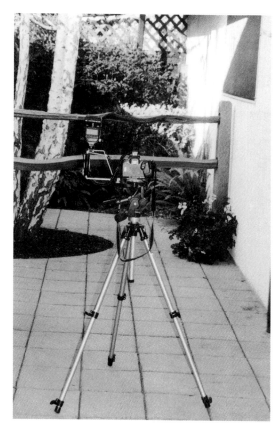

This is a totally secure outdoor shooting area.

We're in a Safe, Secure Place for the "Shoot"

This "shoot" is being done in a totally secure outdoor studio area I've created. There's an eight-foot-high wooden fence on three sides. The fence is specially constructed to prevent any distracting lines of light from showing between the boards. A building's wall on the remaining side completes this safe, oblong enclosure. The background plantings provide a natural-looking setting. The white birch tree can give me natural framing, and sometimes it's a prop. The rail fence is a movable prop. Lots of electrical outlets are available for studio flash units, which I like to use here.

Lighting Details

Once I've placed my lights, I turn off the modeling lamps, because dogs find that more comfortable. Overhead are panels made of sun-screening materials that reduce sunlight by 50 percent. I can add sailcloth above, as well, to reduce harsh sunlight even more, whenever it might be needed.

I've placed my main light (a variable 400 watt-second studio strobe) on the viewer's left. It is mounted high on a light stand, aimed down—note it creates slight shadows from the dog on the viewer's right. My fill light (another variable 400 watt-second unit), also on a light stand, is to the viewer's right, beside the camera and me, aimed directly at the dog's face. The fill light has a translucent diffusion screen and is set to produce half as much light on the subject as the main light, thus giving me the 3:1 lighting ratio we discussed in

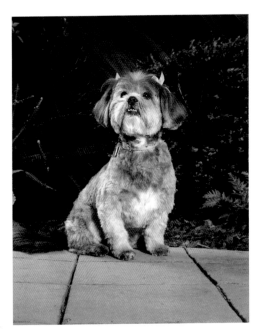

A

B

chapter 9. I'm using a flash meter held at the subject's position to measure the amount of light each of my studio units is projecting on my subject dog. Reading the output from these lights separately on my flash meter allows me to be certain of their relationship to each other. A bit of filtered sunlight provides the only light on the background shrubs and fence, which are somewhat out-of-focus to keep the viewer's attention on the dog, while maintaining the look of an outdoor setting. The lines on the "tile" will lead the viewer's eye toward our subject.

If the sun is your main light, with your subject positioned to be lit like this little dog is in these examples, you can duplicate this setup with a single diffused strobe unit or off-camera flash. It's really simple to set up this way for a 3:1 lighting ratio.

The Resulting Photos

The first photograph (photo A) is a good beginning. Our subject's sitting at a nice forty-five-degree angle to the camera, but she's looking up too high, and, though her collar has been turned to hide the tag on it, we didn't turn it far enough. Not good.

Next, in photo B, we've got her looking down where we want her to look, and her collar is properly turned to hide that tag. Notice the nice catch lights in her eyes that our fill flash is giving us. I wish her mouth weren't open, but this is a good "happy dog" look.

C1

C2

D

E

It's all pulling together in the third shot (photo C1). A clap of my helper's hands caused the dog to close her mouth for a moment. This works well as it is, full frame, but we could also crop to just her head and chest for a more dramatic portrait from this negative. See the suggested alternative crop (photo C2).

In photo D, we can tell that she's had enough photography for the moment. Time for a break!

So, while her "person" was petting our subject, we brought in a "posing table," a wicker coffee table that was sturdy enough for this small dog. We put the dog on the table with her favorite toy. I like natural materials for props with dogs, if the prop is going to show in the final shot. Lighting remained the same, but we draped a black velvety cloth behind the table, and raised our camera, mounted on a tripod, to the dog's new eye level. The full-frame view in photo E centers the dog's head too much. I'd crop the finished photograph on the right and bottom to improve the composition. Remember the rule of thirds.

Next, we changed the backdrop to a color that complements the bows and collar (it's the same color, but a slightly darker shade). The black backdrop in photo F is more dramatic and provides greater impact, I believe. I like our subject's expression, looking in the direction of the main light. It's important that fur entirely outlines the dog's right eye in this shot—the eye away from the camera. The white area in the lower-right corner is distracting. I'd crop this area in any prints made from this negative.

In photo G, this little cutie looks comfortable as she intently looks into

the camera (it's those strange, curious little noises I make), and is clearly at ease. Again, remembering the rule of thirds, I'd crop the top and left to increase the impact of this shot.

My favorite shot from this session is photo H (page 128). It's one I seriously considered for the cover of this book. It exemplifies what we've been talking about throughout the preceding pages, and it gives a wonderful look into the psyche of a marvelous and personable little canine.

The Unseen Moments of the Session

This group of pictures highlights the twenty exposures I made of this charming little dog. I don't want to bore you, so I didn't include those shots that are too similar to those included here. Nor did I include the shot with the owner's hand touching our subject on the chest to reassure her and help keep her in position. That one was an example of poor timing on my part. It still happens. When I'm photographing many dogs in one day, as I would at a show, for instance, I find that I usually need only about five exposures to capture a truly professional-quality portrait. It amazes me how often I choose the first exposure as the best shot of a series. That's a reminder to have everything set correctly, from the very beginning. However, remember what I told you earlier: shoot lots of film. I do when I'm working in my studio or in the field.

In the studio, I change things as I shoot, adding a posing table, bringing in a favorite toy, changing backdrops, etc. Each change dictates the need for

H

an additional series of photographs of the subject. I consider a "shoot" to be successful when my client has a great deal of difficulty choosing which photograph of their special canine friend they may want. And, of course, I never object when they want to buy more than one. I know this little dog's special person was pleased with our results.

I hope looking through my lens at these results and reading about what went on behind the scenes during this photographic session will help you to apply all we've discussed in this book, and to achieve the doggone great creative canine photography you're striving to produce.

About Your Finished Photographs: Crop and Improve

Over the years, I've taught animal photography to professional photographers and amateurs, and I'm often asked to judge their work. About twice each year, I manage to work in the time to serve as a judge for members of the Southern California Association of Camera Clubs. It's always a delight for me to see the wonderful photography these dedicated amateurs are capable of producing.

When I judge, I try to share some of the thoughts that pass through my head as I look at any specific photograph. All too frequently, I see photographs with subjects presented dead center, or photos with horizon lines that cut the photo into two equal portions. Avoid both, if you can. You'll create more dynamic, vital photographs that way.

Now, judge-like, I'm going to share some additional thoughts with you. Hopefully, my comments will help you look at your finished photographs with a fresh eye. And maybe, just maybe, my thoughts will help you improve some of the photographs you've already made.

Avoid Distractions

The human eye is attracted by white. If there's something white in your photograph, that's where the viewer will look first, or to the area of greatest contrast. The impact a photo makes is generally determined by what the viewer sees first. Once the viewer has looked at the photograph, what, then, holds the eye? Avoid visual distractions, props, framing devices, and so forth, which compete with, or overpower, your subject. Remember, everything in your photograph should contribute to the overall impact your canine subject makes on the viewer. If something in the photo doesn't contribute to the image you're trying to create, then it's weakening it. Crop it if you can.

For example, while the photo on page 130 might reflect a cute concept, it doesn't work well because the black puppy is visually lost behind the atten-

Unfortunately, this cute pup disappears behind the attention-grabbing white chair. Generally, it's best to avoid using white props.

tion-grabbing white chair. Moving in closer to the pup, cropping the chair drastically, might have salvaged this shot, but I have serious doubts that even major cropping can save this one. Lighting on the puppy is good, and the exposure is correct, maintaining detail in the mixed-breed pup's black fur, but those things wouldn't save this photo from scoring low due to the lack of visual impact of the pup.

Shooting Images You Can Sell

Shoot vertical images, as well as horizontal. If you ever hope to sell your images for publication, remember that the shape of a single page in a book or magazine is vertical. You can create vertical images from your horizontal shots through cropping, but it is a good idea to include verticals from the start. If you're shooting for the cover of a magazine, this is especially true, as all covers are—of course—vertical. And here's another tip for potential cover images: Leave room around the dog for type to be added.

By the way, along the line of thought about selling images, if you do want to sell any images of dogs you may have created, you must have a signed property release from the owner of the dog. Release forms are available in many camera stores. Most are long, rather complex forms full of legal language which tends to put off the animal's human companion, often making them hesitant to sign the form. I use a simplified form, which reads:

PHOTO RELEASE

I give Photographer, [your name], permission to photograph me, my animal, and/or my property, and to use or sell the photographs as the photographer wishes.

The form has lines for a signature, with the person's name to be printed below, full address (including zip-code), and the day's date. I've never had a problem with anyone refusing to sign this simple form, and I won't photograph an owned animal without having this form signed in advance. I'm not a lawyer, though, and you may want to discuss this with your legal counsel.

This vertical photograph of a Boston Terrier was one of a series created for a December magazine cover. The vivid red background and Santa-embellished container helped create the holiday appearance.

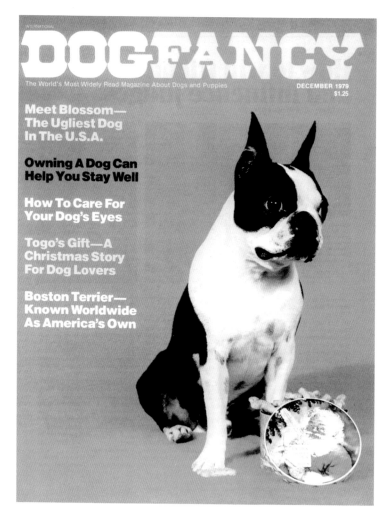

This was the photo the editors selected. Leave room around the dog for type to be added, as in this cover for *Dog Fancy* magazine.

Move In

While judging, I'm often shown a photograph of an animal that includes so much foreground or background (or both!) that I'm not too sure exactly what the maker had in mind when the picture was made. If you're creating a photo of a dog, make sure the canine subject is the dominant object in your photograph. Move on in, either by physically moving closer with your camera, by zooming in with your telephoto lens, or by cropping the final image. If in doubt, take the picture both ways: full body plus the setting, then just the full body of the dog. And while you're at it, photograph a third (vertical?) composition as well by capturing just the face of your subject, too. It's easier to do this in-camera during your photography session, but you can create all three versions through cropping the most all-inclusive image.

To help me with cropping, I created both vertical and horizontal versions of a homemade device on clear plastic (see page 132, left). I place it under my

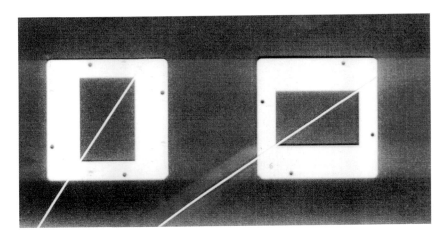

These cropping devices help me improve my photographs after I've captured the images on film. They're especially helpful in creating the best placement of my subjects to provide maximum impact in the final images.

glassine-protected negative or slide (above, right), or overlay it on a print, to make sure that, when I crop, I get the correct proportions, while eliminating any unwanted portions of the image. I try to make sure the diagonal line goes through that portion of the image I want to emphasize, like the animal's face, or right between the eyes in a close-up portrait. Anywhere along the diagonal line, I can indicate new edges for the cropped version of the photograph, as long as the diagonal touches both lower left and upper right corners of the new, cropped, image.

While we're on the subject of cropping: I try to avoid including only parts of legs in portraits of canines. Legs that are cut off tend to lead the viewer's eye out of the picture, and partial "amputations," though only visual and not real, are nevertheless unattractive. If you see that happening in your viewfinder, change your perspective a bit. Zoom in to eliminate any part of the legs from your photo, or zoom back to include the full length of the legs and some ground beneath the paws. Just don't visually amputate a leg in your photographs—in the field or on the light table. That's not humane, and it's not good canine photography, either.

Also, while we're talking about legs, avoid having any limbs appear in your photographs that are not visibly connected to an animal's body. That's something to be aware of before you get to the cropping stage, whether you're photographing wild, or domestic, canines.

As you employ these techniques—both in your viewfinder and in your

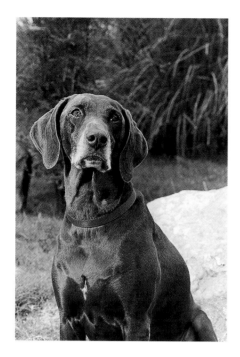

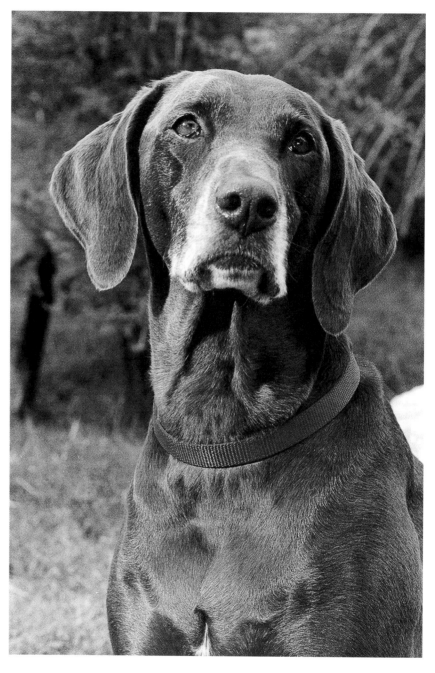

These two photographs of a German Shorthaired Pointer illustrate the importance of cropping a portrait to avoid having the dog's legs become leading lines, which direct the viewer's eye out of the photograph. I do like to include the animal's chest in a portrait like this, providing more substance to the canine subject, and providing a solid visual base for the dog's head and neck.

workroom—your creative decisions should answer the following questions: Does this photograph reflect your imagination? Does it generate imagination in the viewer? Is this a fresh approach to your subject? Is your cropping creative, or is the subject shown creatively? Strive to make your photograph art, and you'll achieve the kind of creative results I think you've been seeking.

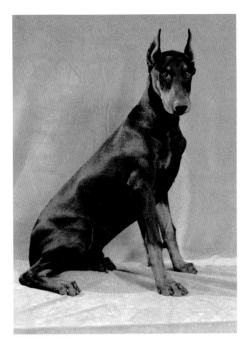

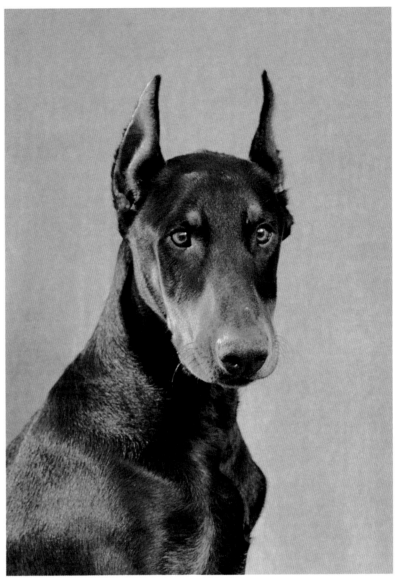

Sometimes, cropping can change the mood or personality shown in a subject's photograph, as in this example of a young Doberman Pinscher. In the full-body, seated version, the dog looks unsure and shy, in large part due to its body language. However, in the cropped version (from the same negative) the young dog appears to be more Dobe-like, sure of itself and intense.

Color Correction

You can correct color in prints by working with your photo lab. If you notice that color is off a bit in your proof prints, talk with your lab about correcting this. A whole series of filters is available to them for this purpose, but it's up to you to give them complete and accurate directions about what you want them to accomplish or color-match. There are also filters available for computers to increase color, saturation, and contrast. You can even get software for your computer that increases the sharpness of focus selectively in a photograph, such as the Nik Multimedia Filter Suite, Color Efex Pro, and Sharpener Pro.

This black and white photograph of an Irish Setter in an outdoor setting has a lot of appeal, but . . .

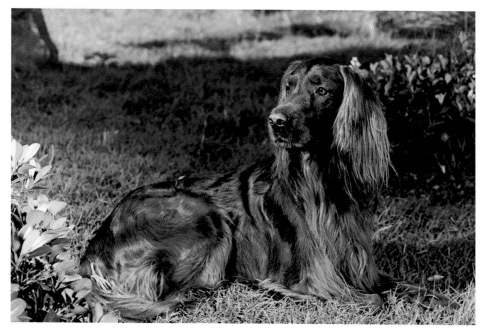

In color, and having cropped the foreground and right side only a bit, tightening on the dog itself, the same photograph of the Irish Setter has a lot more visual impact.

Composition, Style, and More

As I look at photographs made by others when I'm judging, or at the results of my own photographic efforts, I react to the composition, the sense of style, color balance, and lighting—all things we've talked about earlier in this book. I think, "Does this photograph stand out? Is the maker's approach to this subject different, or real? Does the photo have individuality?" I also look for good placement of the canine subject, and of any additional, or lesser, subjects that might be included in the photograph. Is the arrangement comfortable, har-

Though this portrait of a Siberian Husky ignores the rule of thirds, the dog's placement in the photograph works. There's good eye contact through the camera, and you can almost imagine he's about to "speak." Both add impact to this photograph of a strong subject captured simply and up close. The use of off-white fabric behind the subject provides good color balance with the dog's coat. The lighting produces excellent tonal contrast and textural detail.

monious? Once again, remember the rule of thirds, but don't be a slave to it. There will be times when you want to ignore that rule completely. Know what your reason is for doing it when you do ignore it, however.

Color balance and lighting also catch my attention when I look at any photograph. I like to see a coordination of color between the canine subject and the background. Is it creative, or interpretive, or even abstract? I look for what can only be termed a successful execution of lighting arrangements. Does the lighting help create a mood? Lighting does reproduce the characteristics of the canine subject, the center of interest of the photograph. How dominant do these elements make the dog?

And finally, I check to see how well the photograph interprets the canine subject. Is the camera angle appropriate? Are the dog's strengths emphasized? Does the photograph have good tonal contrast? Does the canine subject's expression contribute to the overall impact of the photo? Does the image make a statement or does it tell a story? If so, can the viewer get the complete meaning from even a single glance?

Sometimes, It Takes Two

Occasionally, the best way to improve a photograph you've already created is to combine it with another photo. This can be done, more or less mechanically, by sandwiching two slides. A successful sandwiched image could combine a vivid, color-saturated photo of a sunset with another image of a man and his dog running on a beach, as I once did in an award-winning effort. Silhouettes especially lend themselves to this type of treatment. In other applications of this technique, you have to decrease each of the exposures by one f-stop. Once you place the two slides together, you're back to a "normal" exposure. Placement of the elements in the "new" composition is the key to successful sandwiching. Once again, plan ahead.

Computers allow you to place elements from two or more photos in a new composition. The result is called a composite. The difference between a sandwich and a composite is that you'll use only those elements from each photograph that you want to include in the finished composite, rather than being forced to use the entirety of both photos, as in the sandwiching process. I've created a number of highly successful digital images this way, combining a wolf pack from Canada with a lone wolf peering around a tree in the United States, for instance, and others, like the illustration shown here—the "classic" coyote howling at the moon.

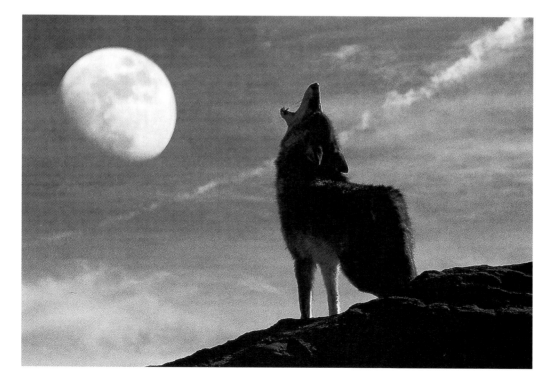

The moon, taken from a photo made by Nancy Varga, was added to the sky in my photo of a howling coyote to create this digital composite.

This successful photograph of three Samoyed nine-weeks-old pups exemplifies good composition (note that wonderful triangular shape), interesting lighting, and technical excellence. It includes no visual distractions, and it's tight on the subjects. This photo is a "keeper."

Edit without Prejudice

Don't allow yourself to make excuses about your photography. When you edit your photos, edit without prejudice. Either a photograph is successful, or it isn't. The best place for those images that don't reach your goals—is the wastebasket. Only by ruthlessly tossing those images that miss the mark will you be able to share with others photos that are true winners.

Eyeing the "Perfect" Image

Composition, style, color balance, lighting, good placement of the subject, happy mood, a good camera angle (at eye level), and the canine's pleasant expression all contribute to the successful execution of this portrait of a wonderful companion animal, a Standard Poodle (page 139). And doesn't this image look more pleasing than the view I showed you on page 43? Standard Poodles are outdoor dogs, and so I placed him in an out-of-doors setting (sorry, Poodle people, there was no body of water readily accessible to show off his true heritage, though he is sitting on the cover of a spa). He's looking to the viewer's left, so the viewer's eye moves into the dog's face at first glance. Sunlight provides both cross lighting and a hair light on top of the dog's head.

This Standard Poodle is one of our "grand-dogs," and our daughter and son-in-law named him "Chocolate Mousse," which got shortened to "Moussie" (pronounced Moosie).

There's excellent detail in the dog's fur because we used flash fill set at half-power—that is, at one f-stop underexposure (–1). Because it's mostly in the shade, the background does not compete with the dog's image, though detail is visible.

Hopefully, knowing how one photographic judge views photographs will help you create better photos. However, understand that each person who views your photography is, in effect, judging it. And every single person will probably react somewhat differently to what they see.

You remain the most important judge of your own photographic efforts. Now you know the rules, the guidelines, we've discussed. But you should also have the courage to forget those guidelines—bend 'em or even break 'em—when you believe doing so will improve your photograph. That's the point of creative canine photography, or any other type of photography you choose to

pursue creatively. Set your sights high. Enjoy striving to create canine photography that pleases your own discriminating tastes. Persistence and patience, combined with an understanding of canines and knowledge of what makes a good photograph great, will pay off. The number of photographs you create that take our breath away will be the measure of your work as a photographer of canines; not just the number of photos you take.

Happy snapping, and good luck. I hope you experience the same kind of joy and satisfaction from working with all kinds of wonderful canines over the years ahead, as I've been privileged to experience in my career as a photographer of canines.

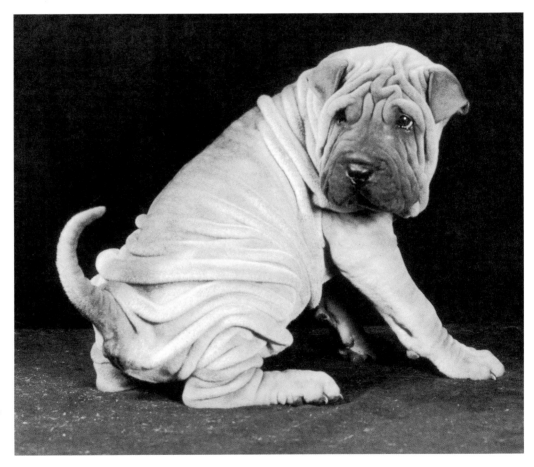

Some day the coat might fit. The pose and the lighting emphasize the most distinctive characteristic, the wrinkled skin, of a young Shar-Pei puppy. And this is . . .

THE END

Index

Page numbers appear in italic for photographs.

Books from Allworth Press

Allworth Press is an imprint of Allworth Communications, Inc. Selected titles are listed below.

Mastering the Basics of Photography
by Susan McCartney (paperback, 6¾ × 10, 192 pages, $19.95)

Photographic Lighting Simplified
by Susan McCartney (paperback, 6¾ × 9⅞, 176 pages, $19.95)

Mastering Black-and-White Photography: From Camera to Darkroom, Revised Edition
by Bernhard J Suess (paperback, 6¾ × 9⅞, 256 pages, $19.95)

Creative Black-and-White Photography: Advanced Camera and Darkroom Techniques, Revised Edition
by Bernhard J Suess (paperback, 8½ × 11, 200 pages, $24.95)

Starting Your Career as a Freelance Photographer
by Tad Crawford (paperback, 6 × 9, 256 pages, $24.95)

Photography Your Way: A Career Guide to Satisfaction and Success
by Chuck DeLaney (paperback, 6 × 9, 304 pages, $18.95)

Talking Photography: Viewpoints on the Art, Craft and Business
by Frank Van Riper (paperback, 6 × 9, 320 pages, $19.95)

The Business of Studio Photography, Revised Edition
by Edward R. Lilley (paperback, 6¾ × 9⅞, 336 pages, $21.95)

How to Shoot Stock Photos That Sell
by Michal Heron (paperback 11 × 8½, 160 pages, $24.95)

Photography: Focus on Profit
by Tom Zimberoff (paperback, with CD-ROM, 8 × 10, 432 pages, $35.00)

The Photographer's Assistant, Revised Edition
by John Kieffer (paperback, 6¾ × 9⅞, 256 pages, $19.95)

Pricing Photography: The Complete Guide to Assignment and Stock Prices, Third Edition
by Michal Heron and David MacTavish (paperback, 11 × 8½, 160 pages, $24.95)

Business and Legal Forms for Photographers, Third Edition
by Tad Crawford (paperback, with CD-ROM, 8½ × 11, 192 pages, $29.95)

ASMP Professional Business Practices in Photography, Sixth Edition
by the American Society of Media Photographers (paperback, 6¾ × 9⅞, 432 pages, $29.95)